PAINTING FLOWERS

PAINTING FLOWERS

CREATE BEAUTIFUL WATERCOLOR
ARTWORKS WITH THIS STEP-BY-STEP GUIDE

ARCTURUS

JILL WINCH

Dedicated to Paul, Neil, Katie, and Sarah
and to all my precious little ones

ARCTURUS

This edition published in 2015 by Arcturus Publishing Limited
26/27 Bickels Yard, 151–153 Bermondsey Street,
London SE1 3HA

ISBN: 978-1-78404-743-6
AD004575US

Printed in China

CONTENTS

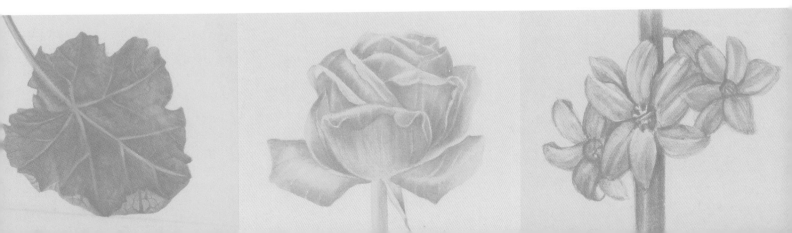

INTRODUCTION

This book is designed to help you get started on painting floral subjects, and then to develop your skills. Of course, a love of flowers is a good starting point but practice is key to achieving success, and although it might be tempting to skip the exercises at the beginning of the book and begin with an exciting floral portrait, they should not be ignored since they will start you on the right road to lots of enjoyment and artistic satisfaction.

Watercolor is the most popular medium for painting flowers, and although it can be considered challenging, you will find that you can achieve success by using the correct tools and techniques. The best way to tackle it is to start with exercises that are easily achievable, rather than trying something difficult and becoming discouraged. I find my students get stressed about ruining a piece of paper they are working on, but they needn't be; there may be many pieces of discarded paper along your road to success, but with each piece, more lessons will have been learned about what you do and don't do. There is a process to work through, and skills gained by practicing will give you the confidence needed to move on to the next stage — making a painting to be proud of.

Finding a regular class to join and keeping an eye out for more specialized workshops can be helpful in the understanding of this huge subject. The Internet can be an excellent source of information, and on a smaller scale, a local art shop can often advise on nearby art societies that hold painting sessions. Art groups often invite artists to give talks and demonstrations from which there is much to be learned, and joining a group brings many other benefits, such as meeting like-minded people and making friends as well as picking up tips on painting. I am still in contact with people I met in a painting group I attended 20 years ago, and I know that the friendships made within the classes I hold now are invaluable to those attending.

However, if you join a group, be careful not to constantly compare your work with that of other members. In many instances, the only person holding us back is ourselves and our own lack of confidence; someone in the group who seems much more skilled than you could ever be has probably just had a lot more practice.

As you become more ambitious, finding a teacher with whom you have a good rapport is important. Having been very lucky with my teacher when I was first studying botanical art, I know how important it is to have someone who encourages you and is also able to show you how to paint — someone who is not only an excellent artist but also an excellent teacher (thank you, Isabel).

Exhibitions are an excellent form of education, since looking at how botanical artists have used their chosen medium will help you form your own ideas of how you would like to use your watercolor or pencils to achieve the results you admire. In time, you may find the confidence to enter your own work into an exhibition.

Looking through books of botanical art is a lovely way to find out how other artists have applied their paint and arranged their compositions. I feel you cannot have too many books, and I treasure all of mine for when I can find some quiet time to immerse myself in the wonderful world of painting flowers.

Jill Winch

Materials and equipment

Over the next few pages, we will look at the materials and equipment you will need for your flower paintings. These include pencils for your initial drawings, along with brushes, colored pencils, paints, and papers. The range of art materials available in stores and online is wide and consequently rather bewildering to a novice artist, so it is useful to understand what you want for your particular purposes before you start shopping and perhaps waste your money buying unsuitable items. Generally speaking, buying the best materials is the ideal thing to do, but if you are on a budget, there are ways to spend your money wisely rather than wasting it on poor-quality materials. We shall also discuss the equipment involved in painting flowers in particular, including vessels for holding them.

Pencils

In terms of mark-making, pencils can vary according to brand, and in time, you will discover your own preference. The standard graphite pencil comes in a range of hard or soft leads, with H1 to H9 progressively harder and B1 to B9 progressively softer. HB is the midpoint. For the purposes of this book, I recommend you acquire the range from 2H to 2B. The HB is a good all-rounder, ideal for your initial drawings and easily erased before you apply your first watercolor wash.

Other types of pencil on offer include mechanical clutch pencils, which I favor. These are available in sizes 0.3, 0.5, and 0.7, and the graphite leads can be changed according to what is required, so rather than have several pencils, you can use just one with different lead strengths. I prefer a 0.5 holder, usually with either an HB or 2H lead inserted, filed down with an emery board to achieve a fine point. The thickness of this lead gives me the stability I require.

Mechanical pencils are similar and cheaper to buy, but they usually contain quite a fine lead, and the leads are more difficult to change, so the saving on price is not really worth making.

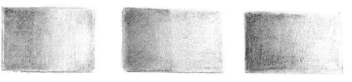

Mechanical clutch pencil **Standard graphite pencil** **Mechanical pencil**

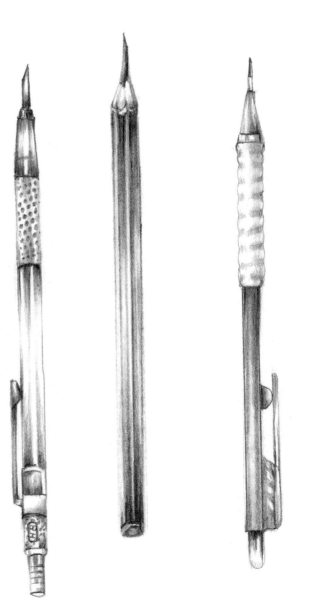

Pencil sharpener

I use two types of pencil sharpener: desktop and a small handheld sharpener. These both come in various styles by different manufacturers, and your choice will be down to personal preference and availability.

Eraser

I prefer to use a small blue putty eraser, for which there is a gray equivalent from a different manufacturer. These are extremely pliable and wonderful for rolling over your initial drawing to remove excess graphite. There is a white one that is more generally available, but you will find this is not as elastic as the blue or gray one.

A recent find is the Design eraser made by Caran d'Ache, which is perfect for removing graphite pencil or colored pencil completely.

Pliable putty eraser in blue or gray

Caran d'Ache Design eraser

Colored pencils

The use of colored pencils as an alternative to watercolors is fairly new for flower painting. Art supplies manufacturers have now developed top-quality pencils that produce good lightfast colors that can be used in exhibition work. An ideal medium for those who have a love of drawing, the pencils make a natural progression from graphite through to color. The Faber-Castell Polychromos is an oil-based pencil, while Prismacolor Softcore and Caran d'Ache Luminance are wax-based.

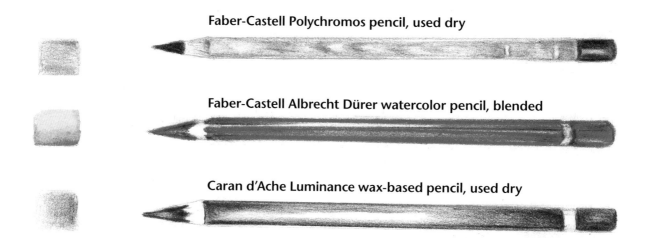

Faber-Castell Polychromos pencil, used dry

Faber-Castell Albrecht Dürer watercolor pencil, blended

Caran d'Ache Luminance wax-based pencil, used dry

Copic Empty Marker Pen

Prismacolor pencil blender

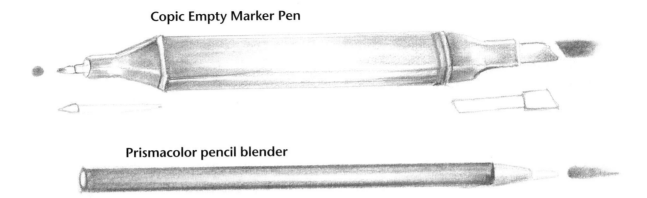

All can be blended totally dry, or you can apply baby oil to spread and blend the color using a cotton bud, paper stump (tortillon), or a double-ended Copic Empty Marker Pen, which has a chisel end for spreading the colored pencil with broad strokes and a pointed end for finer work. You can also blend these colored pencils with a clear pencil blender, although it does not spread the color as smoothly as the baby oil does. Watercolor pencils may be used either dry or with water. (See pp. 102–111 for more advice on using colored pencils.)

Watercolor paints

The majority of my watercolor paints are made by Winsor & Newton, though I occasionally use some from other manufacturers. Note that colors do vary between manufacturers — while the name of the pigment may be the same, the color in the tube may be darker or lighter, for instance.

Artists' colors are the top of the range, while the Cotman watercolors are made to Winsor & Newton's usual high-quality standards, but costs are reduced by replacing some of the more costly pigments with less expensive alternatives.

Watercolor pigments come in transparent, semitransparent, and opaque colors (though opacity with watercolor is relative, since the medium is famed for its translucency). You can buy them in tubes or pans. My preference is for tubes; I have used pans but usually find I am left with a well in the center, which can be irritating. Winsor & Newton supply paintboxes containing a comprehensive range of watercolor pans which can be a good way to get started, although you may find that a lot of these colors will be wasted as they will not be used in flower painting — hence my recommendation for tubes, which are a little more expensive individually but will last for years.

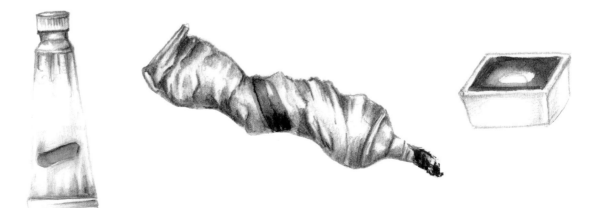

Brushes

While good brushes are pricey, it is definitely worth investing in some because they will hold the paint well and last longer than cheaper ones, which may split after being used only a few times. I nearly always use sable brushes for watercolor painting. Sizes 2, 3, and 4 will be sufficient for your needs, with a smaller size 1 for fine detail. Except for detail, I do not advocate using a tiny brush for painting — my preference is for a larger size with a good body and fine point — this will hold a good amount of liquid, so that there is no need to continually reload the brush with paint. My size 1 brush is used only for fine detailing, such as hairs or fine veins. I also use what is called a retouch or spotting brush, which is excellent for producing a small round spot, useful for the markings in foxgloves, for example.

The one exception to my sable rule is a synthetic brush with a short flat head, which is useful for removing color from the paper (see p. 37).

Magnifying glasses

I strongly recommend buying a good handheld magnifying glass to give you the detail required for flower studies. Choose one with a large lens in order to see plenty of your subject, giving anything from 2× to a 5× magnification — the range available is wide.

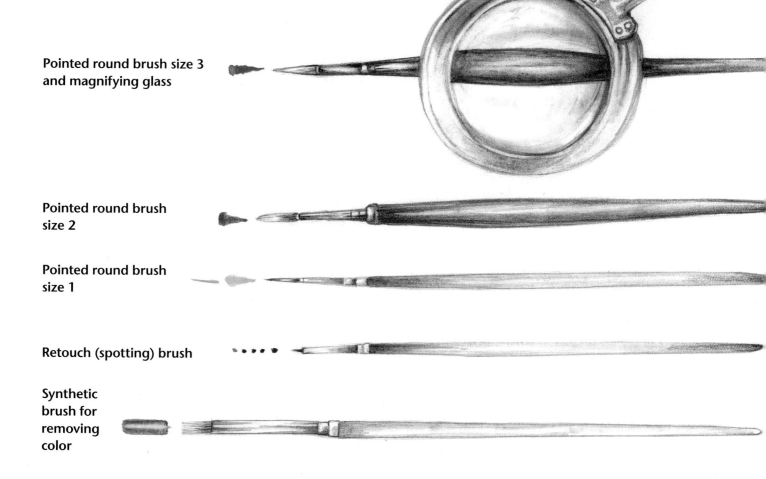

Pointed round brush size 3 and magnifying glass

Pointed round brush size 2

Pointed round brush size 1

Retouch (spotting) brush

Synthetic brush for removing color

Palettes

My preference as far as palettes go is simple: the one illustrated on the right is perfect. Made from enameled metal, it has plenty of sections in which to apply your watercolors from your tubes and space for color mixing; it is also easy to wash clean and has a lid. When you use tubes of paint, there is often some pigment left over on the palette, and rather than wash it off, you can just close the lid to keep it clean. Although the pigment will not retain its softness completely, it can be easily returned to its former consistency with a small amount of water.

Metal palette

Also illustrated is a ceramic palette with five wells for paints and space for mixing colors, nice and sturdy for home use rather than for outdoor painting. I advise you to avoid plastic palettes; although they are light to carry on outdoor painting trips, I find the paint collects as a droplet on the brush and does not spread well.

The simplest palette of all is a white china plate. Use the outer rim for your colors and the center for mixing. Cover it with some plastic wrap when it is not in use to stop any dust from accumulating on leftover pigment.

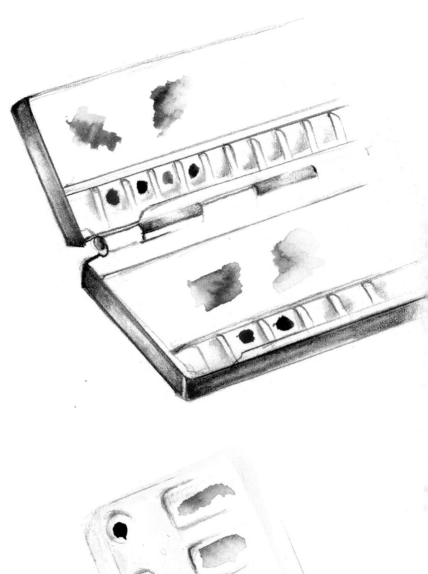

China plate

Ceramic palette

Paper

For my flower painting, I use Fabriano Artistico Hot Pressed (HP) paper, 140lb (300gsm) in weight. HP paper has a smooth surface that is equally good for colored pencil work. Some artists prefer to use the extra-white version as it will not have an underlying impact on the color used.

This paper can also be used for loose wet-into-wet work, although some artists prefer a Cold Press (Not) paper, since this has a surface texture and can absorb far more moisture without cockling. On the right you can see the different effects of pencil on Cold Press paper (above) and Hot Press paper (below).

Paper is available in pads, though I prefer to purchase it by the sheet as this gives me the option to cut it to whatever size I need. Novice artists tend to work on a sheet of paper that is too small; it's best to use something larger than you think you will need, which gives you the option to make notes and color matches outside the image.

The best tactic is to work within a drawn frame before putting paint to your paper. You can even work out your design on tracing paper (preferably 62 lb/90gsm) beforehand and transfer it to the watercolor paper using a light box. If you do not have one, you can simply tape the tracing paper against a well-lit window and lay your paper over the top.

In traditional botanical painting, flowers are shown at life-size. Therefore, a small flower like a foxglove will require detailed work on a small scale, whereas a large plant may need to be drawn in sections and moved around to fit on your paper (see pp. 88–89 for an example of this). You may wish to take a more relaxed approach to sizing if you are a beginner.

Cold Press (Not) paper

Hot Press paper

Drawing boards

All that is needed as a support for your work is a board large enough to take the size of paper you will be working on. This can be as simple as a piece of MDF cut to size by a local hardware store, though of course you can buy drawing boards from an art supplies store. I prefer a board with a collapsible stand that gives the board a slight incline. The surface has a wipe-clean coating, perfect for removing any watercolor splashes, and the stand doubles as a handle for carrying. If you want an incline on a piece of MDF, simply lean one end on a pile of books.

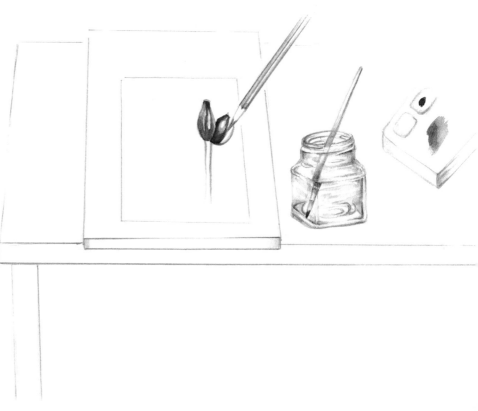

Vessels for holding flowers

For cut flowers, glass containers are particularly suitable, since you can see the stem as well as the flower head. A glass container shaped to hold a bulb with the roots also visible is especially useful. A cheap alternative to buying containers is to use empty jars or bottles, washed clean to stop any bacteria from affecting your cut flower. Florists are usually happy to give orchid holders away, and these are ideal for a cut stem in a small amount of water to keep it fresh. They can either be placed in a florist's oasis to hold them steady, or you can use a flexible holder such as the one illustrated, which can be attached to your drawing board.

Cut flowers are best kept cool to retain their freshness. They will vary, some staying fresh for days, others wilting after just one day, and the speed with which you will have to work depends on this. It is important to record as much information as possible while your subject remains fresh, perhaps using a sketchbook to document details (see p. 24).

Glass bottle

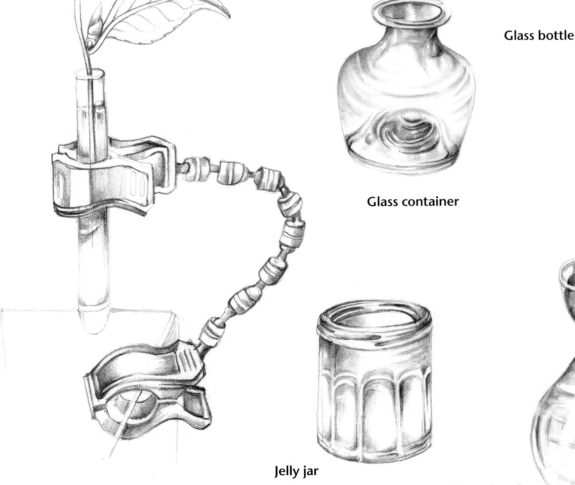

Glass container

Jelly jar

Orchid holder and flexible holder

Container for bulbs

Chapter 1

GETTING STARTED WITH DRAWING

In this chapter, we will start by drawing basic flower shapes in pencil, observing where light falls and applying shadow — in other words, creating form in preparation for translating this information into color. We will look in detail at flower centers and how dissecting a flower head can be useful in helping you to understand the structure of your flower.

A sketchbook is invaluable, since this is where you can record information on your subject in the form of notes, illustrations, color matching, and dissections, before going on to paint your final piece. This initial stage should not be underestimated in its importance, for the practice you will gain here will make all the difference to your results later.

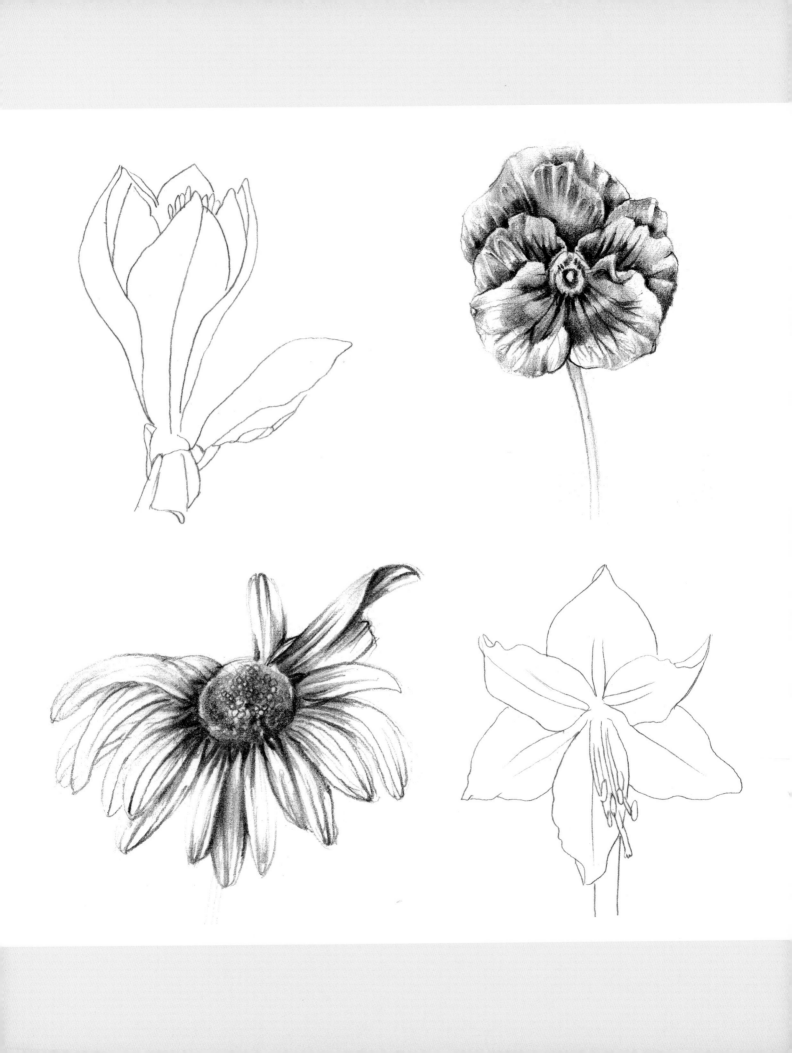

Practice exercises

To start with, I have created some simple geometric shapes based on the different forms you find in flowers: cone-shaped (for example bluebells), bowl-shaped (peonies), cup-shaped (tulips), round (pansies), and tubular shapes for stems. Try drawing these shapes using either an H or HB pencil, then apply shading (tone) to create three-dimensional structures, working from the darkest areas through to light. Notice particularly where the lightest and darkest areas are, since these will later be translated into watercolor, again working from dark through to light.

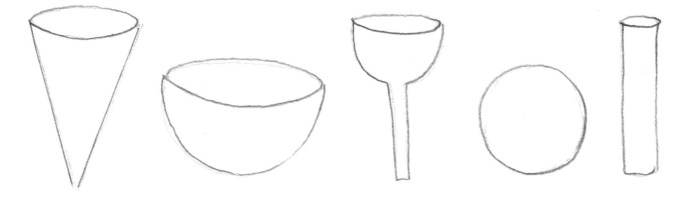

Basic shapes in flower drawing

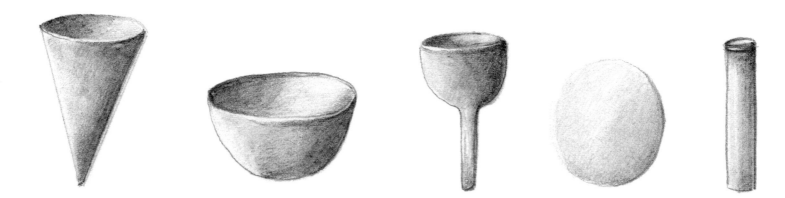

Using tone to create three-dimensional structures

Taking some flower heads, now practice the same technique, using darker tones where one petal overlaps another and referring back to your basic flower shapes to observe where the lightest areas will occur. You can pick your own flowers or copy the examples I have drawn here of a bluebell, a peony, and the front and back view of a pansy. If you are drawing a real flower head, it is important to observe what is in front of you, but you may find it harder to identify the highlights and dark areas. This is why the exercises in tonal modeling above are so important, since they give you an understanding of how to use light and dark to create the convincing form of a flower head.

Using tone on flower heads

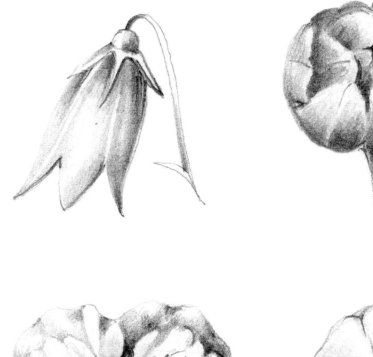
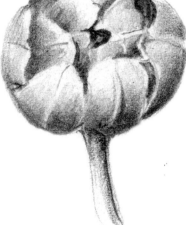
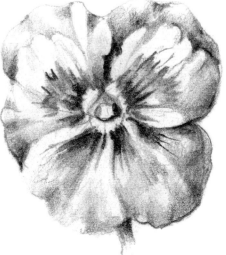
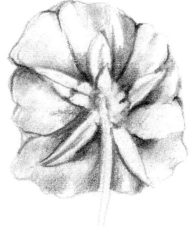

Flower head detail

Here I have drawn the flower head of the marguerite, with its many
overlapping petals. I drew it from different angles and also removed
some petals so that I could observe the center. The many small anthers
in the center were depicted by drawing tiny circles and surrounding
each one with shadow. Try this exercise yourself, and practice applying
shadow where one petal overlaps another, leaving lighter areas on the
open area of the petals.

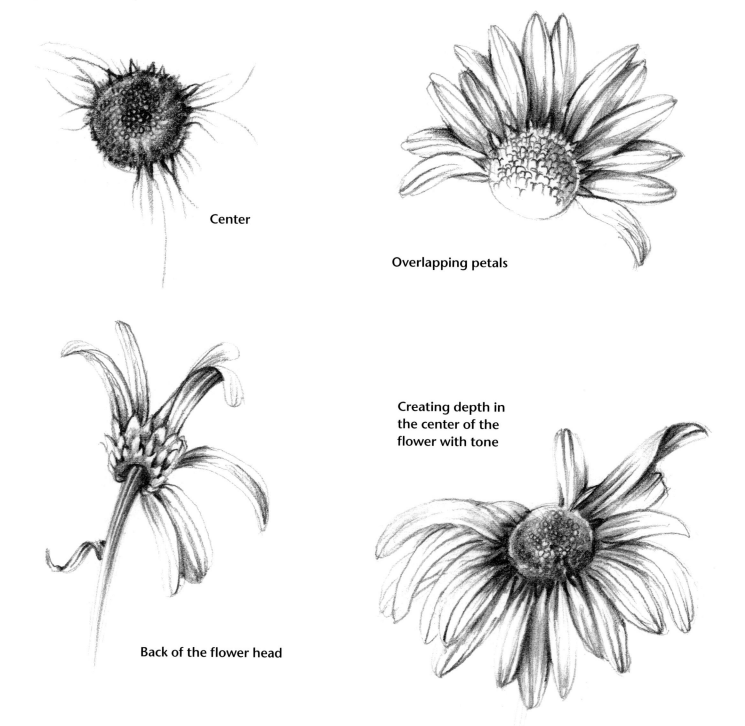

Center

Overlapping petals

Creating depth in
the center of the
flower with tone

Back of the flower head

Next, I drew the centers of three very different flowers: amaryllis, with its impressive curving filaments and stamens; a rose; and a hellebore. Observe the centers of flowers very closely before you try to draw them. You will find a magnifying glass helpful as some of the detail is quite minute.

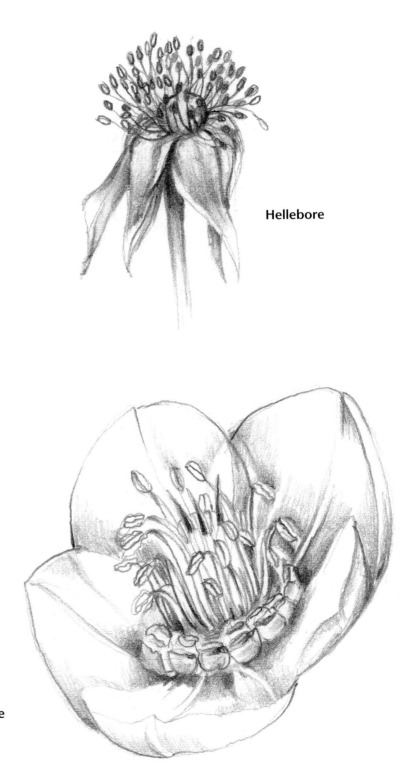

Hellebore

Amaryllis

Rose

Flower heads: three tonal studies

I drew these flower heads on tracing paper before transferring them to the HP watercolor paper, using a light box — you can lay your paper against a window if you don't have one of those (see p. 96). I like to use watercolor paper for drawing, as it has a smooth surface and is of a better quality than heavy drawing paper.

After drawing the outlines in pencil, I rolled over the image with my putty eraser to remove excess graphite, leaving me with a pale gray line. I then proceeded to add tone, using an HB pencil to make small circular ellipses, working from the darkest areas through to the lightest. This enables you to achieve a continuous tonal effect. Gradually lift your pencil away from the paper as you work through your tonal areas. The pencil will hardly be touching the paper in the lightest areas, producing a tone of gray that is barely visible. These images appear again on pp. 22–23, using a neutral tint to practice applying watercolor.

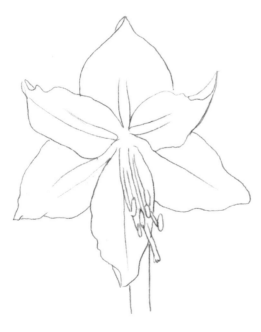

Amaryllis

The first flower head — amaryllis — shows the flower full face with center stamens. The three broad outer petals have had more tone added than the three inner petals, making the latter appear to stand forward. The stamens, filaments, and anthers are also left light, with shadow tone applied behind to give the same effect.

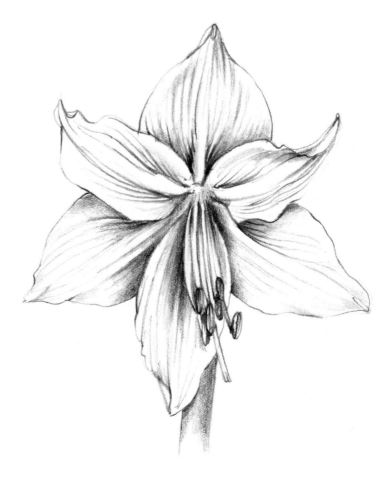

Magnolia

On the opening bud of the magnolia, I made a darker application of tone to the right-hand petals — notice that a fine light area is left where one petal overlaps another. I also reserved lighter areas on the petals to indicate sheen and create the bulging shape of the outer petals.

I added deeper tone to the darkest points of the bud where one petal overlaps another and at the very base of the bud. It can help to have a light pointed at the subject from the left- or right-hand side to exaggerate the areas of light and shade while you practice your grasp of tone.

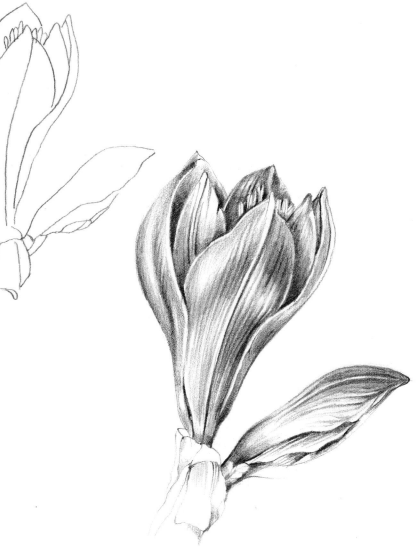

Rose

I used an HB pencil once again for the rose head, applying tone inside where one petal overlaps another and leaving a completely light area at the top of each petal. A heavier application of pencil on the bowl of the rose and the center petals creates a feeling of depth within.

A putty eraser is useful with pencil work if you feel you have added too much tone to your image. By rolling your putty eraser to a point, you can gently lift off pencil in areas where you would like to create more light.

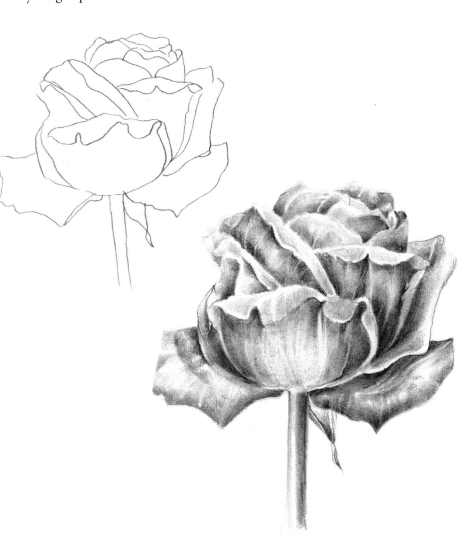

Observing detail

A sketchbook is invaluable, not only for recording various parts of your flower but also for making color notes. To fully understand a flower head, you may find it necessary to remove the petals and expose the flower center. Illustrate your flower from different angles, exploring its form, so that you have a point of reference when you are making your final artwork.

You can see here how I made a simple drawing of a foxglove stem with flower heads before dissecting parts of the plant and making notes and color suggestions. These foxgloves will be used in our flower projects chapter (see pp. 85–87).

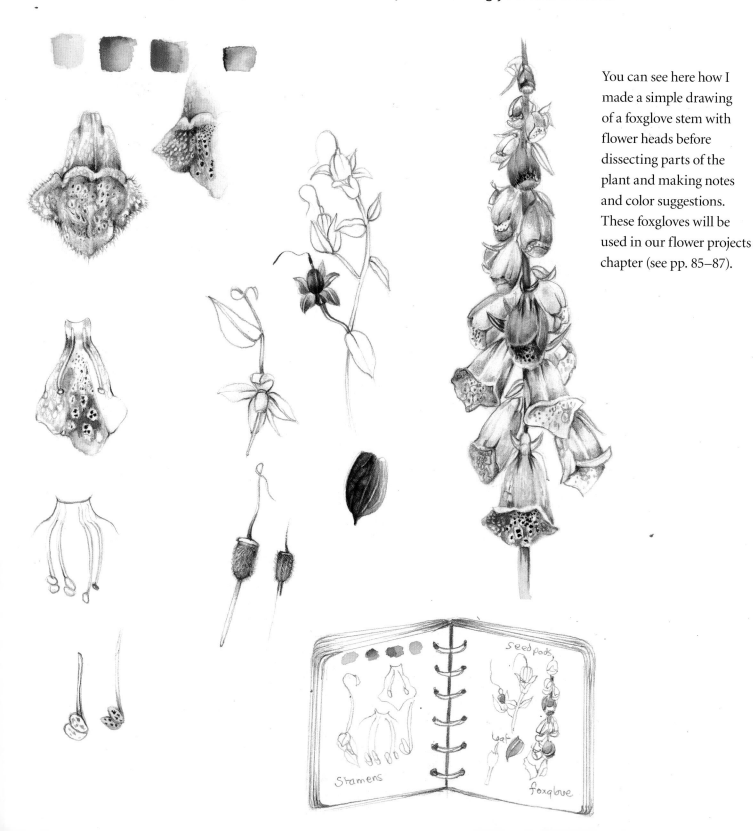

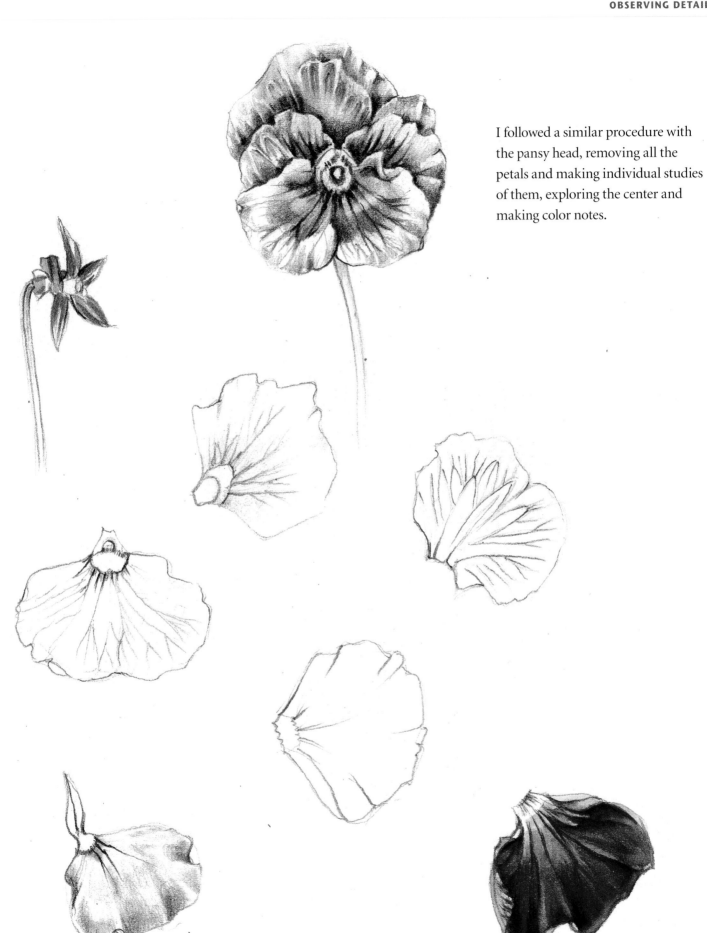

I followed a similar procedure with the pansy head, removing all the petals and making individual studies of them, exploring the center and making color notes.

Chapter 2

INTRODUCING WATERCOLOR

In this chapter, you will find out how to use watercolor, initially working in monotone to avoid the pressure of wondering which colors to mix until you have learned the skills needed to apply a successful wash. We will then explore the use of color with the aid of the color wheel, discovering the primary, secondary, and tertiary colors. As your understanding develops, you will be able to achieve the correct colors for your chosen subject by breaking down the colors that can be seen in flowers and mixing them together. You will also learn classic watercolor techniques such as using masking fluid.

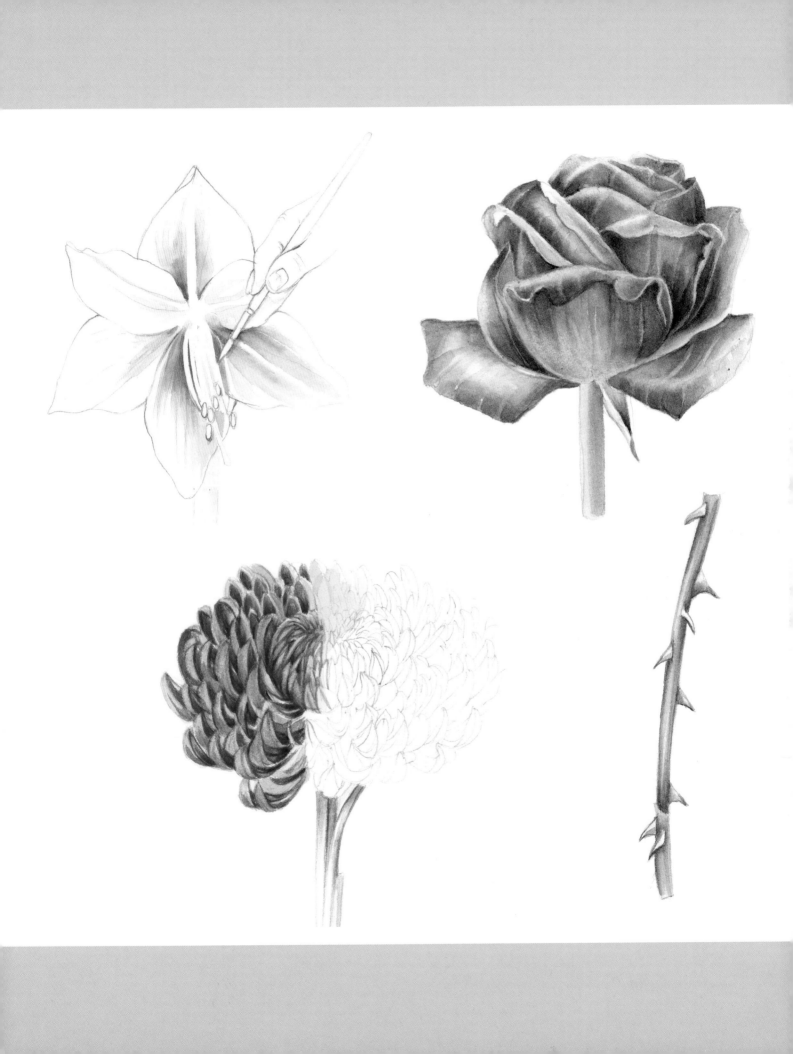

Laying a watercolor wash

The ability to lay a wash is essential for every watercolor painting. Rather than start with the complication of color mixing, just use a single color and practice achieving smooth washes; I recommend Winsor & Newton Neutral Tint, which is a soft gray color. Use simple shapes as in your pencil drawings and try to replicate them, this time with a smooth wash of color rather than tone applied with a pencil.

After drawing your shapes, remove any excess graphite with your putty eraser until you are left with just a faint gray line, and apply a clear wash of water with a damp brush. This helps to prime the paper, enabling further washes of color to achieve smooth transition from darker areas of tone through to lighter ones. It is important not to leave too much graphite underneath, since the water will fix it, and you will be left with an unsightly gray line that will be difficult to remove.

Next, apply your watercolor — Neutral Tint is shown here. Wash out your brush until it is clean, use a cloth to dampen the brush, then go back and move the paint until it becomes so thin that it is nearly back to the white of the paper. This will indicate where your light falls. Your first watercolor wash has been achieved!

Wet the paper

Apply a wash of watercolor

Clean the brush

Wipe off excess moisture

Wash out the paint

Judging the amount of water

Applying watercolor smoothly does take a lot of practice, particularly when it comes to how much water to use on your brush. Here, I have shown examples of what happens to your washes if too much or too little water is used. Wetting the paper with clean water first prevents any hard lines from appearing when you apply further washes to your paper. Experiment by applying washes to one piece of wetted paper and a dry one, too.

Too much water

A line produced by not wetting the paper first

Too little water

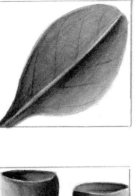

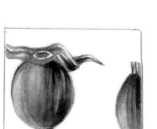

Very much in the same way as you practiced drawing your basic flower shapes with pencil, now do the same with watercolor, using the simple steps to laying a wash set out on the facing page. Take your time when working on these practice pieces, and repeat them as often as you like.

Highlights

To create highlights, you can work watercolor around lighter areas or lift it off with your brush. Two petal shapes are shown here: In the first one, the watercolor is worked around the lightest point on the petal, while in the second, the watercolor has been lifted off to let the white of the paper show through. This second method should be achieved when the paint is still fairly wet, so speed is critical for removing the paint as it will be more difficult to remove when dry.

Working around highlighted areas

Lifting off paint to give highlights

To show that the light is coming from the right, there is a heavier wash on the left-hand side of the tube

Lifting off paint down the center of the tube indicates that the light is coming from the front

Stems and hips

As with your flower heads, practice painting stems with your Neutral Tint. Here, I have shown some examples of stems, including magnolia, a twisted wisteria stem, a thorny rose stem, and a hairy stem and bud.

You can copy the stems shown here or search for your own. Depending on where you are working, light source may become a challenging issue, since it can often appear as if light hits the subject matter in several areas. It is best to decide from the outset where your light source is coming from. I usually work with mine coming from the left-hand side as most botanical artists do, unless they are left-handed, when the opposite usually applies. If you are setting up a workspace for yourself at home, choose to have your desk by a window where the light will fall on your preferred side, left or right.

Apply your paint to your stem, wash your brush out thoroughly, dampen it on your cloth to remove excess water, and wash the color away through to the lightest part. Add a pale line to the opposite side of your stem — nothing too harsh, just a soft line.

For the hairs, I have used white gouache and applied it with a fine brush, size 1. Like watercolor, gouache is a water-based paint, but it is more opaque, so it is useful for details such as this. The hairy stem may look difficult to achieve, but if you take your time and work methodically, your patience will pay off.

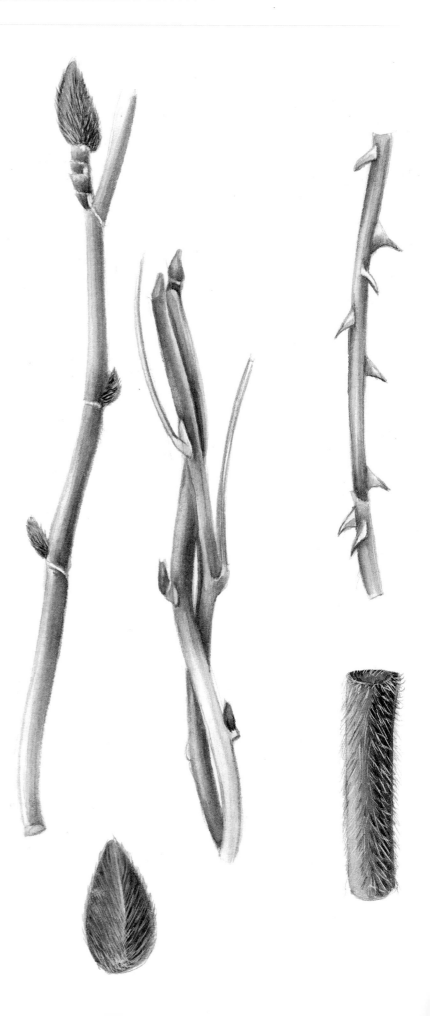

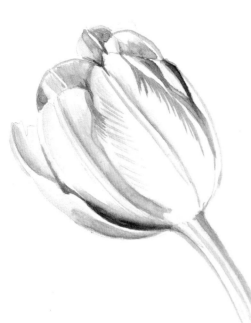

Laying a wash on a flower head

It is important to lay down a clear wash of water before painting your subject. As we saw on p. 28, the clear wash primes the paper, changing the surface, so that you can move your applications of watercolor successfully.

The first tulip head was not given a clear wash of water first. Darker areas were applied with watercolor but unsuccessfully moved, producing an uneven wash of color.

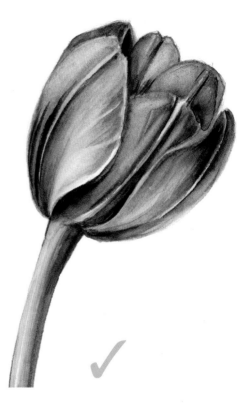

With the second tulip head, I applied a clear wash of water and left it to dry. Then I laid repeated washes of tone, achieving a smoother wash.

Shine

The shine on a glossy leaf or fruit is achieved by leaving the white of the paper blank. Practice is important to get this right, since there should not be any hard lines around your area indicating shine.

Building up washes

Draw the three flower images on pp. 22–23 again, but this time, render them in watercolor. The skills you have just learned with your practice shapes can now be applied to flower heads.

Amaryllis

Take a very light approach with this flower head. Use your Neutral Tint in the shadow areas, then wash your brush out until all the paint has been removed. Remove any excess moisture from your brush by dabbing it on a cloth, and go back and rework the painted area with your damp brush. Your brush will dilute the paint already on the paper, and by working it carefully into the lighter areas of the flower, you can create highlights.

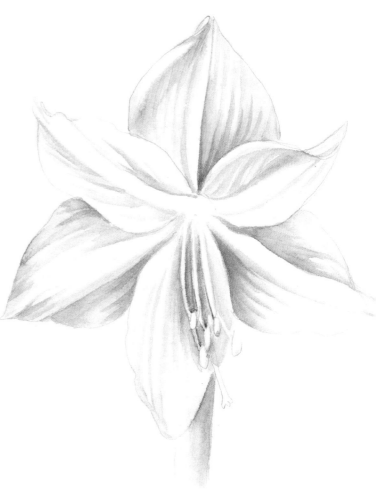

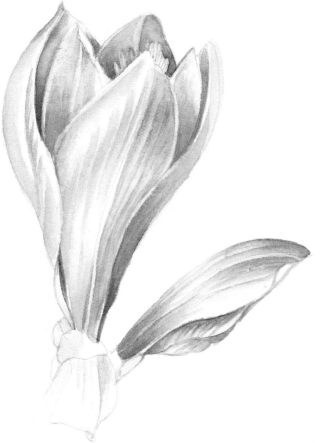

Magnolia bud

On the bud, you will be applying more layers of watercolor. Leave the first wash to dry before applying your second wash, paying attention to your shadow areas, where more depth of color will be required. Practice the same principles, washing your brush out, dabbing it on your cloth to remove excess water, and going back to wash the color through to the lightest part of the paper where your highlights appear. This process, done successfully, will give you a continuous tone effect from dark through mid-tones of color to light tones and the lightest area of the paper, achieving a smooth gradation of watercolor.

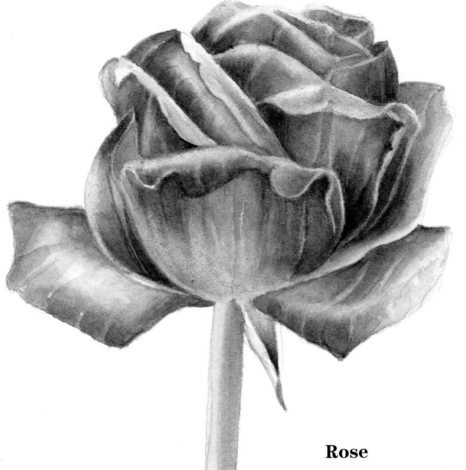

Rose

I used many layers of Neutral Tint paint to build up
the color in the shadow areas of this rose. The areas
of deepest shadow occur where one petal overlaps
another around the bowl shape of the flower head. I
allowed each layer of paint to dry before applying the
next, until I was satisfied I had achieved the depth of
tone required. Building up washes to achieve depth
in this way is excellent preparation for when you
introduce color.

Moving on to color

Now that you are familiar with handling watercolor, you can start considering the many colors you will be using for your flower and leaf paintings.

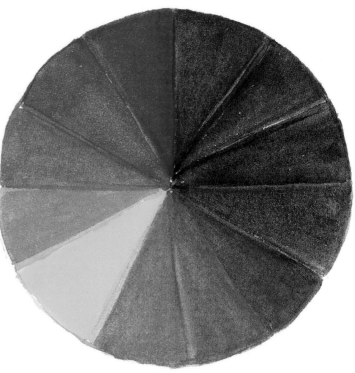

Colors are described as primary, secondary, and tertiary. There are three primaries, red, yellow, and blue, and these cannot be mixed from other colors. Secondary colors are produced by mixing two primaries: Red and yellow make orange; blue and yellow make green; and blue and red make violet. There are, of course, many different reds, yellows, and blues, and the orange, green, and violet secondary colors will depend on the primary colors used.

Mixing primary colors with secondary colors results in tertiary colors, for example, red plus orange makes red-orange.

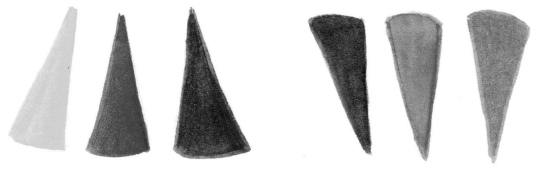

Primary colors

Secondary colors

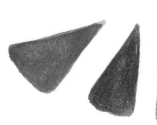

Tertiary colors

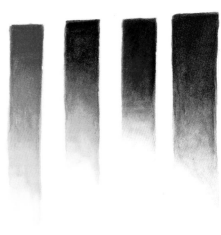

Practice using your secondary and tertiary colors in the same way as you made your initial washes in Neutral Tint, starting with the deep color and washing it away to nothing.

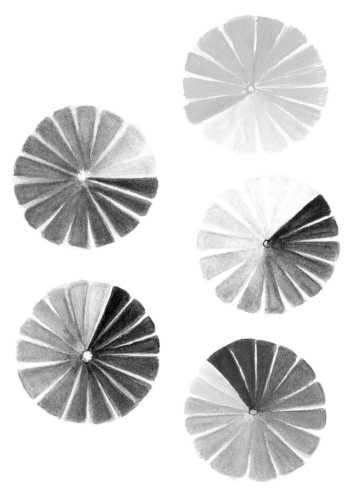

Next, create a wheel with a single color and see what kind of range you can achieve from the darkest hue to the lightest. Here, we have five color wheels showing the primary colors yellow, blue, and red and two from the secondary color range, green, and purple.

It is important to remember that not all manufacturers' colors will be the same and some can vary quite significantly. For the most part in this book I will be using Winsor & Newton paints, although sometimes there will be a preference of color by a different manufacturer.

Opaque and transparent colors

Sometimes you may be unsure if a watercolor pigment is opaque or transparent. A good tip is to draw a line with a permanent black pen, allow it to dry thoroughly, and wash over it with your paint. With a transparent paint, the line will show clearly; if it is opaque, the line will be cloudy; and semiopaque and semitransparent will be somewhere between the two.

Transparency is indicated on paint tubes by a square symbol or by an abbreviation (see below right).

Transparent and semitransparent colors are preferable when painting the delicate petals of a flower, where there is a need to see through the layers of watercolor from one application of color to another. However, sometimes a more dense color is required from semitransparent pigments, particularly with leaves and stems where a more dense color is required to illustrate the solidity of the structure. Opaque color is used mainly when applying hairs or dry brushing to create a bloom.

Aureolin is transparent

Naples Yellow is opaque

Transparent (T)

Semitransparent (ST)

Semiopaque (SO)

Opaque (O)

Applying watercolor to a flower head

Here I have shown a painting of a chrysanthemum flower head in steps, from the initial drawing through to building up stronger color washes. Find a flower head of your own, and practice these steps, or follow the example I have shown here.

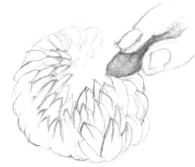

STEP 1 First, I drew the flower head with its tightly packed center petals, then I removed the excess graphite from my drawing using a putty eraser.

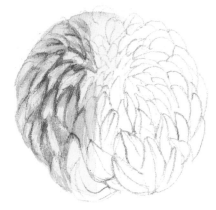

STEP 2 I laid a clear wash over the drawing and allowed it to dry before applying my first wash of color.

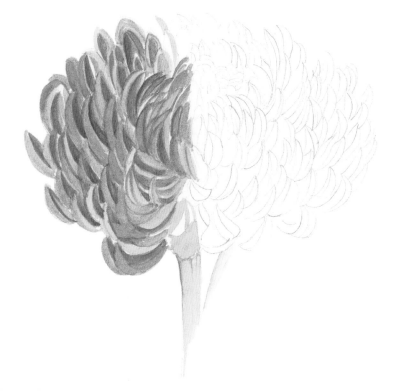

STEP 3 You will notice at this stage that the chrysanthemum head has changed in shape as it opened up. I decided to redraw the flower head to show this. Then I added my initial washes of color, darkening the inside curve of the petals.

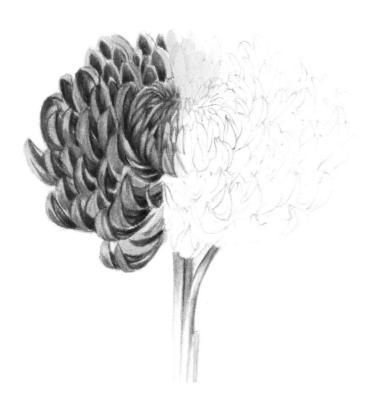

STEP 4 I added stronger color to the inner petals, building up my washes to achieve depth. I felt when reassessing the flower head that some areas should be lighter, especially where the light hit the outside of the petals. It is possible to lift out color, as I have shown below.

Removing color

Color can be removed or lifted off to create lighter areas or highlights on your painting. Here, I have shown how to use a flat-headed synthetic brush (illustrated on page 12) to lift off color on a petal, a stem shape, and a leaf.

Dip the synthetic brush into clear water, and work along the section of color to be removed to produce a highlight. Then wash out the brush, and work along the same section to remove some more color. You can repeat the process two or three times, successfully lifting off color without too much disturbance to the underlying paper.

Two more illustrations are shown where the watercolor has been removed with a brush. In the first, I have removed a broad, straight line of color such as you might find on a stem shape, and in the second, I have lifted off much finer lines of color to show the veins of a leaf.

It can offer reassurance to the painter to know that color can be removed, particularly after paint has been applied too heavily. However, it is a technique for lifting color and not a solution to the mishandling of paint, so if you have applied too much or too little water for your first washes, it is better to discard your painting and try again.

Using masking fluid

When you are painting a flower center, you may find it helpful to use masking fluid, available from any art supplies store, to block out tricky areas such as stamens. Paint it on, leave it to dry, then you can paint over it without worrying about color reaching the area you want to reserve. When you have finished painting the area and the paint is dry, you can remove the masking fluid easily with the tip of your finger, exposing a white area.

The flower head shows the center stamens blocked out. The two squares of color show first the stamens painted over with the masking fluid and second, with the masking fluid removed.

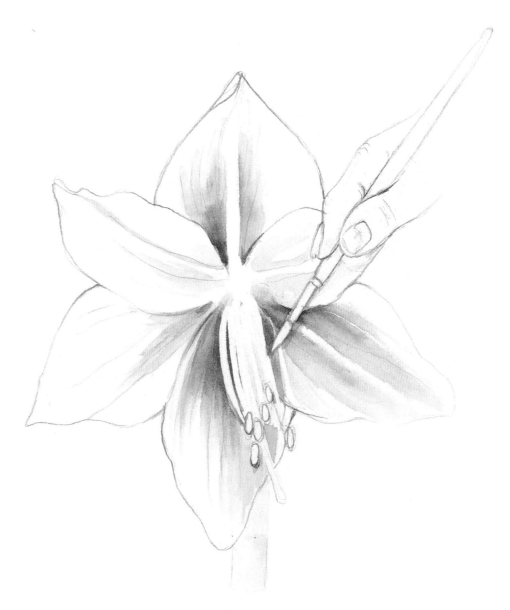

Color matching

Achieving the correct color for your flower can simply be a process of using all of the colors you can see in it and successfully mixing them. I have chosen three examples to give an idea of how to achieve this.

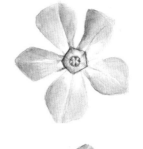

Vinca (periwinkle)

I chose this plant for its simplicity. The flower is a violet-blue color, and by referring to your color wheel, you can see that violet is achieved using blues and reds. As the vinca flower is fairly pale, I used a thin wash of Ultramarine, Cobalt Blue, and Cobalt Violet for my pink element. I mixed the colors until I achieved what I wanted, making color notes alongside the flower. I mixed the green from Ultramarine and Aureolin.

Ultramarine

Cobalt Blue

Cobalt Violet

Cobalt Blue and Violet mixed

Hyacinth

The hyacinth was a deeper violet-blue than the vinca, so when mixing to achieve the correct color, I added more blue to my Cobalt Violet. As you can see, the same colors have been used but in different quantities. The green of the stem was again mixed from Ultramarine with Aureolin, with the addition of the color mix of the flower.

Ultramarine

Cobalt Violet

Mixed together

More blue added

Ultramarine plus Aureolin to make green

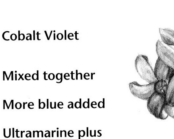

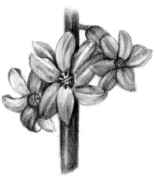

Rose hip

To achieve the orange hues of the hip, I mixed Alizarin Crimson with Aureolin. For the green of the stem, I used Ultramarine mixed with Aureolin, then mixed that green with Alizarin Crimson for the brown sepals, adding some Ultramarine for depth. Blue added to brown gives a good depth to the color, which is worth noting for painting stems in the future. I added a small amount of Permanent Mauve underneath the sepals and also washed it over the stem.

Aureolin

Alizarin Crimson

Ultramarine

Green mixed from Ultramarine and Aureolin

Burnt Umber

Permanent Mauve

Chapter 3

PAINTING LEAVES

In this chapter, we will look at painting leaves and the challenge of achieving the correct colors. During the many years that I have taught botanical painting, leaves have always seemed to be the area that is most problematic and even intimidating. I aim to remove the mystique from painting leaves by giving straightforward information on color mixing and explaining the importance of accurate drawing and the positioning of veins.

We will also be exploring the painting of leaves with a wet-into-wet technique. This method of allowing colors to merge on damp paper can be very enjoyable, even if potentially scary for the artist who prefers a tighter method of painting.

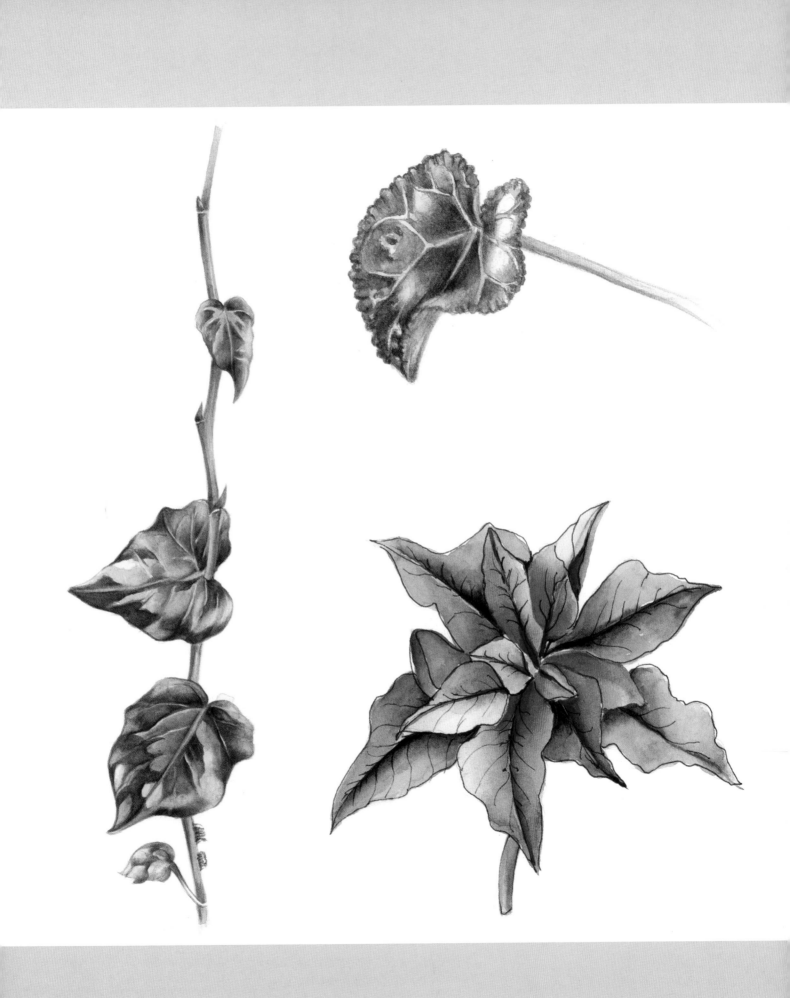

Achieving greens

We know that blue with yellow makes green, but when it comes to painting the huge variety of leaves, the question is which blue and yellow to use. I suggest making color charts that you can refer to whenever you need a reminder of what mixes to use. Some people even laminate their charts for safekeeping.

I have mixed four different blues with the same yellows in each chart to show the variations that can be achieved. The results largely depend on the amount of each color used. It is best to experiment, since a greater amount of blue with yellow will give a stronger bias toward a bluer green and more yellow a brighter green.

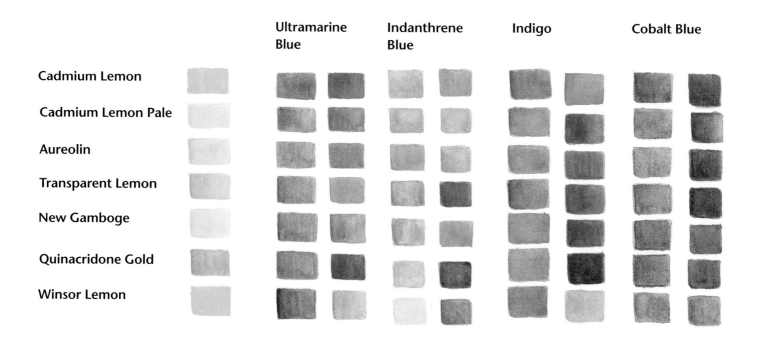

	Ultramarine Blue	Indanthrene Blue	Indigo	Cobalt Blue
Cadmium Lemon				
Cadmium Lemon Pale				
Aureolin				
Transparent Lemon				
New Gamboge				
Quinacridone Gold				
Winsor Lemon				

Ready-made green paints

Terre Verte
Permanent Sap Green
Oxide of Chromium
Holbein Compose Green No. 3
Schmincke Horadam Green Earth
Opaque White

All colors are Winsor & Newton unless stated otherwise.

Mixing different greens for a leaf

You will usually find that you can see different greens within the same leaf. Mixing all the ones you will use on the palette first gives you a good range to work with fluently, without needing to interrupt your flow to find another green. You will sometimes use up a mix sooner than you expected, so make sure that you note color samples on the side or top of your paper to give you a reference so that you can remix the color. Alternatively, make a fresh mix while you still have a small amount of paint left to compare it with.

Do not worry if you cannot find the exact color again; within any leaf, there are a multitude of different greens according to where the light falls, so it will not be noticeable if you have not mixed the identical color.

Leaf techniques

Knowing a few useful techniques for painting leaves will help you get off to a flying start, which will help to build your confidence where this sometimes tricky subject is concerned.

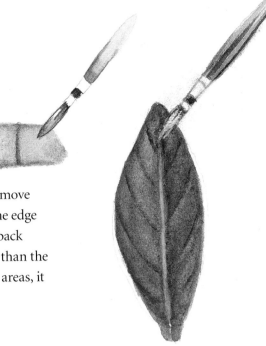

Making a fine vein line

After painting your leaf, you can return with a clean, damp brush and move the paint to create a vein — an excellent method of achieving a very fine edge to a vein. To practice this technique, paint an oblong of paint, then go back with a damp brush and move the paint to produce a line that is darker than the surrounding areas. For leaf veins that are lighter than the surrounding areas, it is best to leave your paper light and build up paint around them.

Dry brush technique

This illustration shows how to use the dry brush technique — inaccurately named in that the brush is still damp but dry enough to achieve this effect. This technique is good for suggesting texture.

Working from dark through to light

To gradate your dark color to light in a small area, take a small dryish brush and gently work the paint. Taking the damp/dry brush, go back to your dark color and gently move the paint, creating a transition from mid-tones through to light tones of color. Because your brush is quite dry and small, you will have plenty of control to be able to do this successfully. This technique is best suited to small sections as in the foxglove leaf (see p. 44) where there are lots of small pockets, and one needs dark and light in a small space.

Removing paint to create light

Lifting off the paint with a damp, clean brush gives the effect of light. This must be done while the first layer of paint is still wet.

Working from a leaf rubbing

Making a leaf rubbing can be an excellent way of understanding the vein structure of the leaf. For this exercise, I placed a piece of 62 lb (90 gsm) tracing paper over the underside of a foxglove leaf, and using a soft 2B pencil, I rubbed over the surface so that the veins were revealed. I turned the tracing paper over and placed it on a piece of HP watercolor paper. With a sharp 2H pencil, I then worked over the lines of the leaf veins. The graphite on the underside of the tracing paper was thus transferred to the paper.

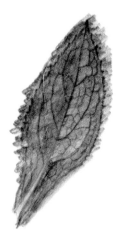

Working up detail

I then applied mixes of Ultramarine Blue and Cadmium Lemon Pale in varying strengths to the leaf, working from dark through to light in each section as shown. The underside of a leaf is usually different in strength of color to the top. I used Terre Verte with a small amount of Winsor Lemon to take the blue edge away from the color. Stronger mixes of Terre Verte and Winsor Lemon were used for the fine veins. The whole leaf was then worked with a damp brush and clear water, reapplying stronger and lighter green mixes where applicable.

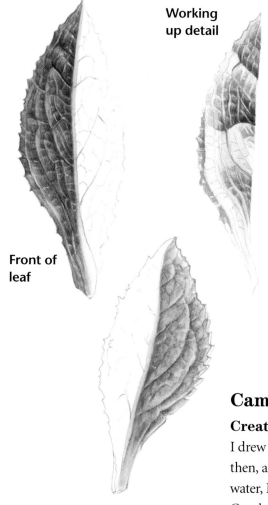

Front of leaf

Underside of leaf

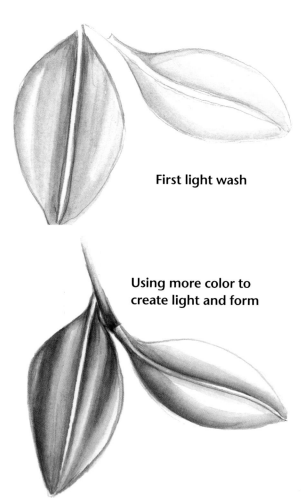

First light wash

Using more color to create light and form

Camellia leaves

Creating shine

I drew the two camellia leaves, and then, after an initial wash of clear water, I applied a thin application of Cerulean Blue, leaving it very pale in the lightest areas. Next, I mixed Indanthrene Blue with Transparent Yellow and applied thin washes until the required depth of color was reached, making sure the very pale Cerulean Blue areas were retained to suggest areas of shine.

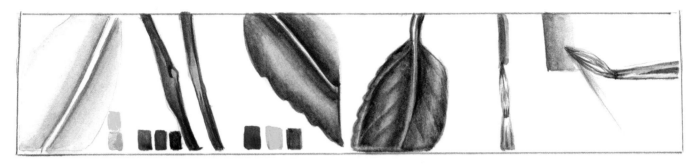

First wash Stems Leaf Leaf and veins Using the brush to create a line Tilting the brush to achieve a graduated wash

Serrated leaf edges

A natural-looking edge to a serrated leaf is achieved by moving the paint after the layers have been built up. With a dampened pointed No. 2 sable brush, gently move the paint away from the edge of the leaf at appropriate intervals.

Veins

Again with your damp No. 2 sable brush and starting from the darkest point of the leaf, drag a fine line from the central vein through to the edge of the leaf. This will give you a more natural-looking vein rather than using some fresh paint.

The stem

The stem was built up with layers of Burnt Umber, to which I added small amounts of Indanthrene Blue for the dark outer edge. I left one side of the stem lighter to create the illusion of roundedness.

Finishing

I applied a thin wash of Aureolin to both leaves and stem. Aureolin is excellent as a final glaze, giving a glow to your subject while adding some brighter color to the blue-green mix of the leaves.

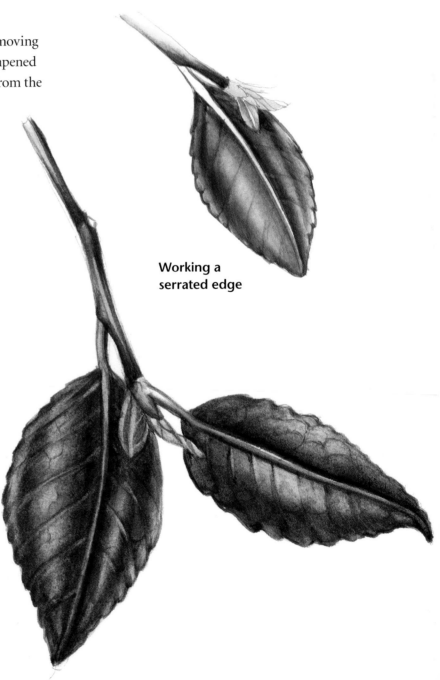

Working a serrated edge

Variegated leaves

Ivy

Ivy leaves are useful subjects on which to practice greens, in particular the variegated cultivar I have shown here. I cut a small stem, placed it to the side of my drawing board, and drew it carefully, first the stem, then the leaves, marking out the various greens and yellows with a pencil. I then proceeded to mix the different greens on my palette.

Ultramarine with Cadmium Lemon

Indanthrene Blue with Transparent Yellow

I gave my drawing a clear wash of water with a damp brush, and once it was dry, I applied a very pale wash of Cadmium Lemon to the leaves.

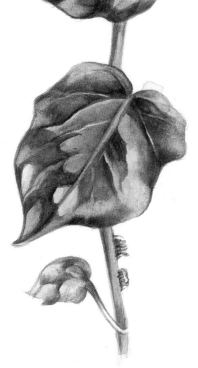

Stem
I gave the stem a thin wash of Cadmium Lemon Pale to one side, then, washing my brush out and dampening it on my cloth, I softened the edge, washed my brush out again, and washed over the remainder of the stem. I then proceeded to make a stronger color with my red and green mix, erring toward the red bias, until I achieved a soft golden-brown color. I added Ultramarine to this mix to make a darker brown, which I used for the buds.

Using my mixes, I applied different strengths of greens, darker or paler where appropriate. Where I needed a darker green, I added a small amount of Winsor Red to my Ultramarine and Cadmium Lemon mix.

Ivy leaf in detail

Here, I have painted an ivy leaf in detail, showing one side in progress and the other side completed. I used a mix of Indanthrene Blue and Transparent Yellow, with the addition of Winsor Red for the darkest parts of the leaf.

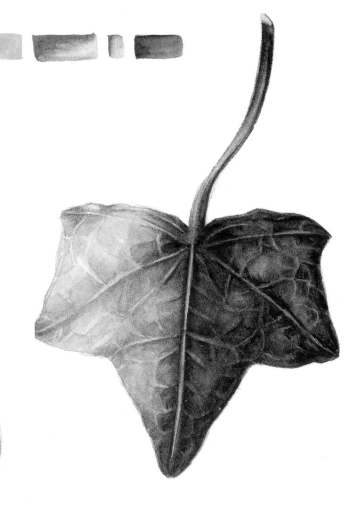

Nasturtium leaf

This is a variegated nasturtium leaf. Using the same green mixes as for the ivy leaf, greens can be created from the palest yellow-greens through to a fresh midgreen color.

Leaf surfaces

The undersurface of leaves is often very different in color from the top. One such example is heuchera, of which there are many varieties, giving stunning leaf colors of deep reds and pale golds. I chose this variety for its leaves, with a pale upper surface and a deep burgundy color on the reverse.

Heuchera leaf

When I am deciding on my watercolor mixes, I often use ready-made colors I see in the leaf. With this in mind, I mixed Winsor & Newton Sap Green with Alizarin Crimson, which resulted in a soft, pale pink color when applied in a very thin wash. Less diluted mixes of both colors with varied proportions of green and crimson produced the stronger brown color seen in the veins.

For the undersurface of the leaf, I used Alizarin Crimson and Ultramarine, since I could see quite of lot of blue coming through the deep crimson color. If you refer back to your color wheel, you will see that these two colors make a red-purple color. For the fine veins, I used a No. 1 brush and a slightly stronger color than that of the base leaf color, carefully applying these markings.

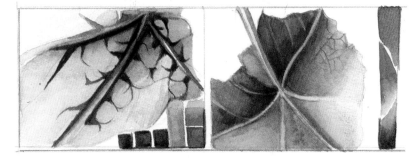

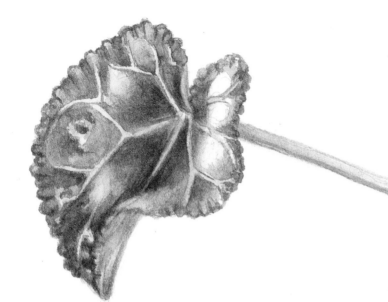

Cyclamen leaves

Another example of differing leaf color according to the surface is the cyclamen leaf. I wanted to retain the very pale silvery-blue markings and used Winsor & Newton Terre Verte, which is perfect for these. I mixed a stronger blue-green with Ultramarine and Cadmium Lemon for the upper surface.

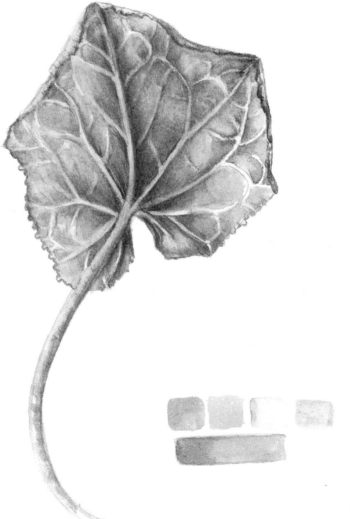

For the undersurface, I used a dilute mix of Cerulean Blue, Cadmium Lemon Pale, and Winsor Red. Sometimes I find green mixes can be a little too bright, but the addition of a tiny amount of Winsor Red achieves a more natural green.

Virginia creeper leaf

The upper surface of Virginia creeper leaves is vibrant in color, ranging from pale yellow oranges through to deep red purple colors, while the underside is much more pale and muted. For the former, I used mixes of Transparent Yellow and Alizarin Crimson, which gave me a good range of colors, from vibrant yellows through to oranges and reds.

For the underside of the leaf, I used Indigo with some Alizarin Crimson, adding a small amount of Aureolin for the yellow tones. This washed out to achieve the paler color I sought.

Colors of course can be mixed in a variety of ways. The color swatches here show first Cerulean Blue, Permanent Mauve, and Winsor Lemon and the second, Indigo, Alizarin Crimson, and Aureolin, both producing the same color.

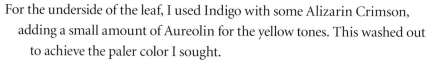

Elaeagnus leaf

Elaeagnus leaves have a beautiful silvery undersurface. For this, I have used Terre Verte with a small addition of Raw Sienna to give the Terre Verte a slightly dirty look, which is ideal for the shadow areas. I applied stronger mixes to the left-hand edge of the leaf and also to one side of the central vein.

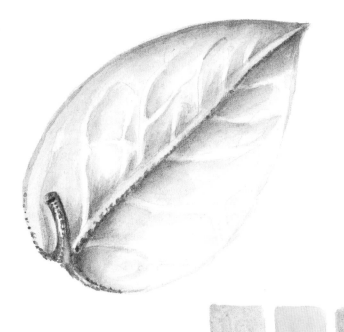

Hairy leaves

This example is from *Stachys byzantina*, also known as "lamb's ears." After the initial preparatory stages, I applied several layers of Terre Verte over the top of the leaf. I put in more detail on the undersurface, using Terre Verte and a small amount of Raw Sienna. Then, using opaque white gouache and a fine brush, I worked the hairs over the top of the leaf as shown. After I had applied several layers, I softened them with a damp brush. The final step was to add hairs to the undersurface, using the same method.

Amaryllis buds and leaves: bright green

Here I have painted the bud and leaves of an emerging amaryllis. Since I wanted a bright, fresh green, I used Cobalt Blue and Aureolin. I often use the latter at the end of a painting if I need to give any of the colors a lift — it is wonderfully transparent and ideal for this purpose. After drawing the bud and flower and applying my clear wash of water, I carefully applied my mix of color, making sure I left plenty of light in the leaves and buds. After this was dry, I reapplied very thin washes of color to build up depth where I needed it, making sure I left the lightest parts with barely any color.

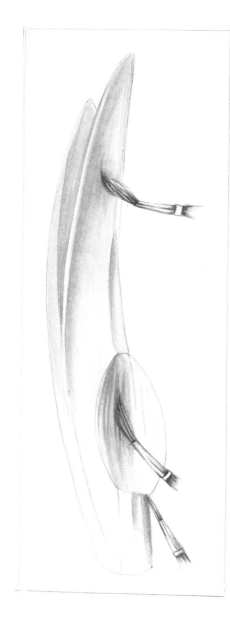

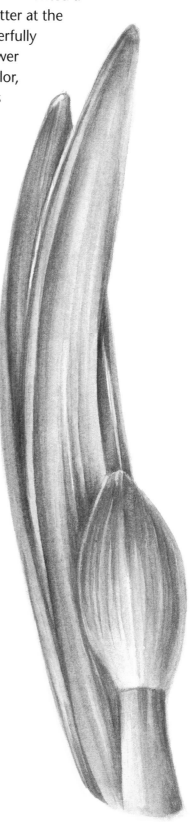

Garrya elliptica leaves: dark green

A favorite plant of mine, *Garrya elliptica* is known as the silk tassel bush because of the beautiful silvery tassels that seem to glow as the light fades. I painted the leaves with a strong mix of Ultramarine and Gamboge, which gives a lovely, rich green, and a darker mix with the addition of a tiny amount of Winsor Red for the shadow areas.

For the tassels, I used the same mix of Ultramarine and Gamboge with just a small amount of the latter, which gave me a very washed-out blue-green. Deeper mixes were added to parts of the tassels with the addition of some Alizarin Crimson.

Painting wet-into-wet

The wet-into-wet technique is a looser style of painting where one color merges into another. It is achieved by dropping color into a first layer that is still damp, producing beautiful colors with soft edges, very different to the crisp edge that results from adding wet onto dry paint, the method we have used so far.

In spite of the name, it is preferable to have a damp rather than wet brush. With this method the paint is not entirely controllable, but watercolor is loved for its unpredictability and the "happy accidents" that occur. Practice with different colors to see the effects you can achieve.

Photinia leaves

Start with something simple for your wet-into-wet leaves. Here, I have cut the top from a photinia bush. I drew this with a pencil, then dropped in the colors Sap Green and Alizarin Crimson to achieve a loose effect.

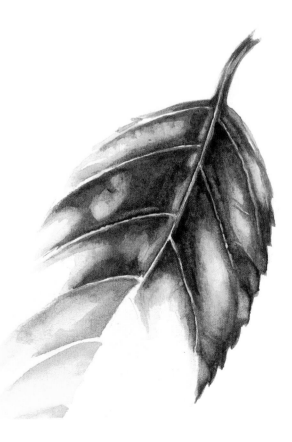

Ivy leaf

Initially mark out where the veins are situated, and drop different strengths of watercolor mixes using Indanthrene Blue and Transparent Yellow onto your damp surface. Work around the light lines of the veins. If you make a mistake, you can lift off color as shown on p. 37.

Pen and watercolor wash

You will need a waterproof pen for this technique, in this case, a fine 0.3 technical pen. I have used a poinsettia here, since it has a good mix of red and green bracts (modified leaves). Draw the bracts first in pencil, placing the midrib and veins accurately, then draw over your pencil lines with the pen. This will give structure to your leaf shape and veins. Wet your paper, and while it is still damp, drop in your color and allow it to spread. Before it is completely dry, drop in your next color and continue in this way.

Permanent Magenta	Permanent Sap Green
Perelyne Violet	Alizarin Crimson
Winsor Green Blue Shade/Quinacridone Gold (green mix)	Permanent Magenta

Alternatively, you can add the pen after the paint, as I did with this lobelia. Use a similar technique but this time apply your color over your drawing first, dropping color onto color to achieve the effect required. When you are happy with the result and the piece is completely dry, add the pen marks. These do not have to be completely accurate and can come within the paint or even outside the edge of the watercolor. I was attracted to this lobelia because of the lovely depth of color — deep purples with bright undertones of greens, ideal for a looser style of painting where one color can merge into another. Having first drawn the stem and leaves and applied a clear wash, I randomly used Winsor Green Blue and Quinacridone Gold, which make a lovely, vibrant green, along with Perylene Violet and Quinacridone Magenta to brighten that in some areas.

Fall leaves

Dried fall leaves are useful for practice since they have lots of twists and turns, plus interesting colors of a depth that presents a challenge.

Here, I have collected some fall leaves and pinned them on a board, so that I could work on them over a few days.

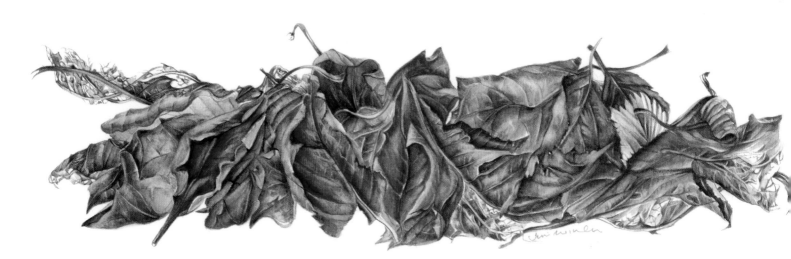

This dried magnolia leaf with its gold and rich brown colors caught my eye. The addition of blue gives an even more intense, rich brown. Burnt Sienna, Burnt Umber, Raw Sienna, and Indigo were the main pigments I used here, from pale washes through to more intense color application.

Hosta "Halcyon"

The leaves of this hosta are among my favorites, not only in the summer months with their soft blue-green foliage but also as illustrated here, in their desiccated form with intriguing colors. They keep well throughout the winter months, an excellent source for practicing your watercolor techniques when there is little plant life to paint.

I applied Raw Sienna as a base, then used Permanent Mauve, Quinacridone Gold, Burnt Sienna, and Burnt Umber, with Daniel Smith's Moonglow added in parts.

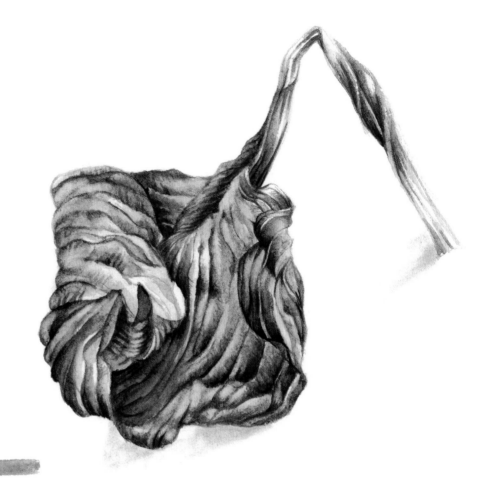

Fall leaves palette

Quinacridone Gold	Burnt Sienna	Burnt Umber	Raw Umber	Terry Harrison Shadow	Raw Sienna
Burnt Umber and Indigo	Permanent Mauve	Permanent Mauve and Raw Sienna	Burnt Umber, Raw Sienna, and Indigo	Moonglow	Moonglow and Burnt Umber

Chapter 4

PLANT STUDIES

In this chapter, we will move on to painting all parts of the plant — flowers, stems, leaves, and berries — so that you can further develop the skills you learned in the previous chapters. It can be thrilling to see your flowers come to life as you gradually build up your color washes to create velvety textures and deep colors or apply the most delicate washes of color to portray white flowers on white paper.

Painting a complicated structure such as that of a hyacinth or applying fine hairs to soft pink foxglove flowers can seem daunting, but you will find step-by-step guidance to help you through. Understanding how to match colors will enable you to achieve successful paintings and take the anxiety out of using watercolor, a wonderful medium but one where you cannot erase mistakes. Practice is the key to success.

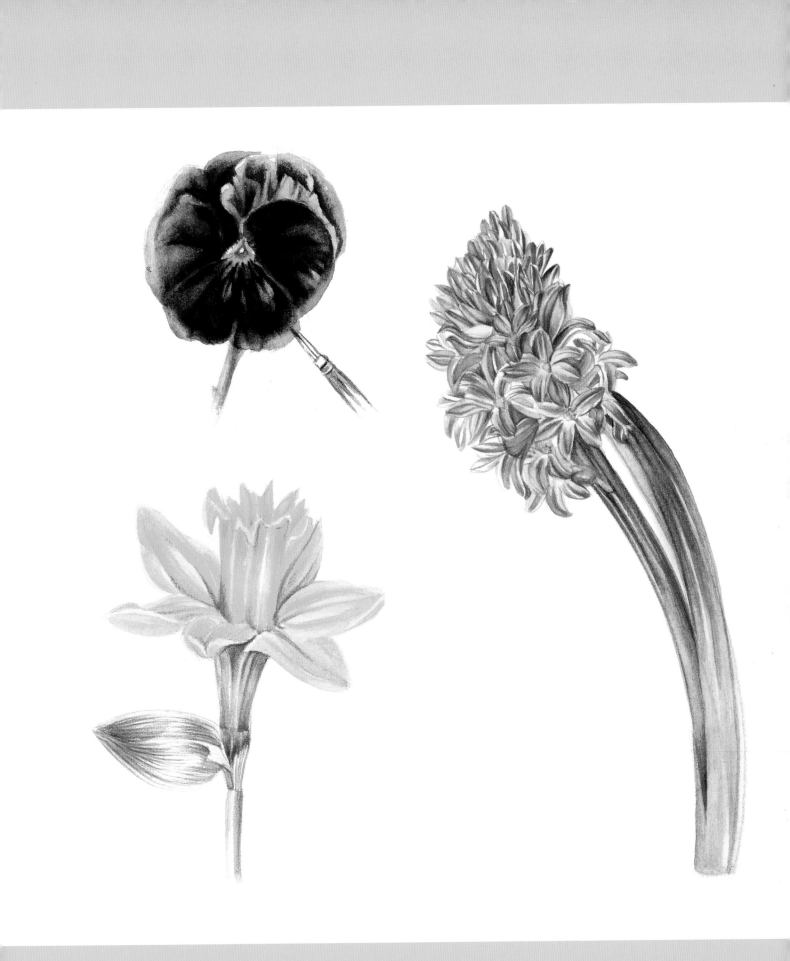

Stargazer lily: bud through to open flower

Lilies come in many colors with various markings. Their scents range from slight to a heavy perfume that some find intolerable, so caution is advised when purchasing one for painting as you will be sitting in close proximity to it for a considerable time. Stargazer lilies have only a slightly sweet smell, so should not present a problem.

Buds have a beauty all of their own. Here, I have made several studies of a lily, starting from a tight bud, through to the opening of the bud, where the stamens become visible, and finally the open flower.

For the buds, muted shades of pink were needed in thin washes of color. The shape of the bud is simple, which makes it easier to draw and paint.

As the bud opens, it reveals the large orange-brown anthers. These are centrally attached to the filament and are able to move — touch an anther with a pencil to see this. The anthers are often removed because they stain clothing if they come into contact with it, but this seems a shame as they command such elegance and are essential to the look of this flower, particularly for painting.

If possible, examine the anthers under a magnifying glass before painting them to gain a true knowledge of their structure. They can be fascinating to study and should not be depicted just as an orange blob, since they do have a beauty all of their own. I used Burnt Sienna to paint them with a size 1 brush and applied Burnt Umber to add definition. Some Permanent Mauve in the center where the filament joins the anther added depth of color.

Draw the bud shape

Remove the excess graphite

Lay clear wash of water followed by first wash

Lay down more washes and begin to add detail

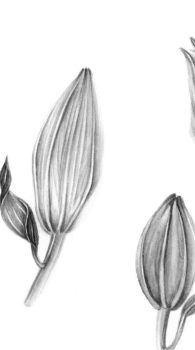

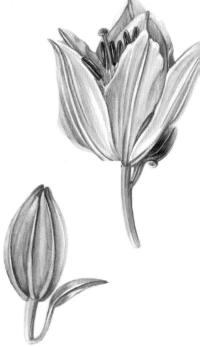

Lily center – a different technique

The treatment for the center of this lily was slightly different in that I used my flat acrylic brush to remove color. For this technique, wet the brush and move along the section of color to be removed, then clean the brush and work over it a second time. You will see at this stage if there is any color left to come away. Do not scrub at the paper since you risk damaging the surface.

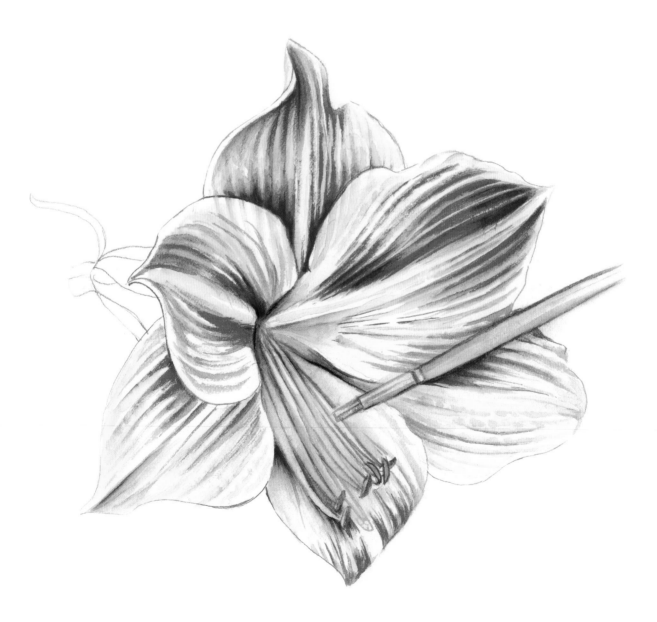

Pansies: velvety texture

The name of this flower comes from the French word *pensée*, meaning "thought;" thus, when a bouquet of pansies is given to you, it means, "I'm thinking of you". Because of its tricolor hues, the pansy has been considered a symbol of the Holy Trinity. Pansies come in a variety of colors, the dense ones taking on a velvety look, especially around the center.

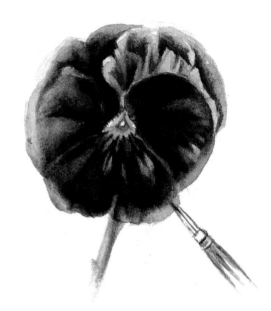

The way to create the texture when painting this very pretty flower is to layer color, waiting for each wash to dry before adding the next, until the intensity of color has been built up to the required depth. This sometimes requires nine or ten washes of color. These different transparent glazes of color can be seen when lifting color away, for example, from the edges of the petals.

For example, if a dark velvety purple is required, first paint a thin wash of Cobalt Blue, followed by Permanent Rose, Winsor Purple, and Ultramarine. Repeat this process until you feel you have achieved a velvety look. Finally, using a clean, damp brush, move some of the paint to reveal the underlying colors.

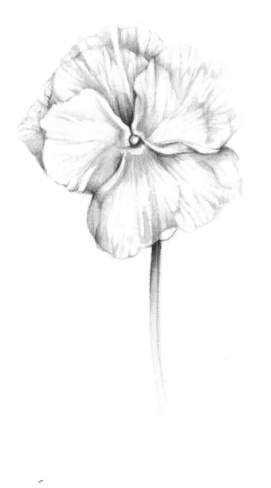

For a white pansy, wash your shadow mix in the dips and shaded areas you can see, starting with the lightest of applications and building up according to the intensity required to give definition where the petals overlap.

 Terre Verte

 Raw Sienna

 Both combined

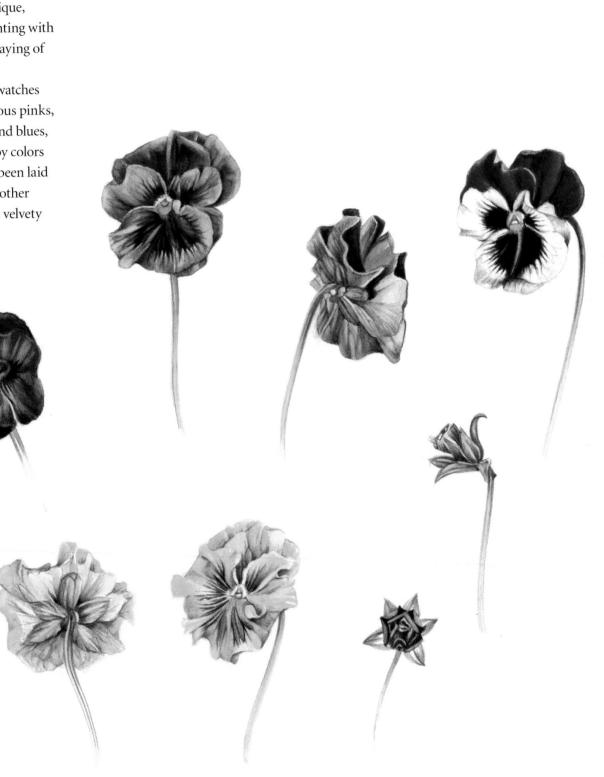

Collect some pansies of different colors and practice this technique, experimenting with your overlaying of colors.

The swatches show various pinks, purples, and blues, followed by colors that have been laid over each other to create a velvety texture.

Daffodils: achieving the correct color

Some people find daffodils quite difficult to draw. Dissection of your flower will help you to fully understand it and thus make your initial drawing easier to achieve.

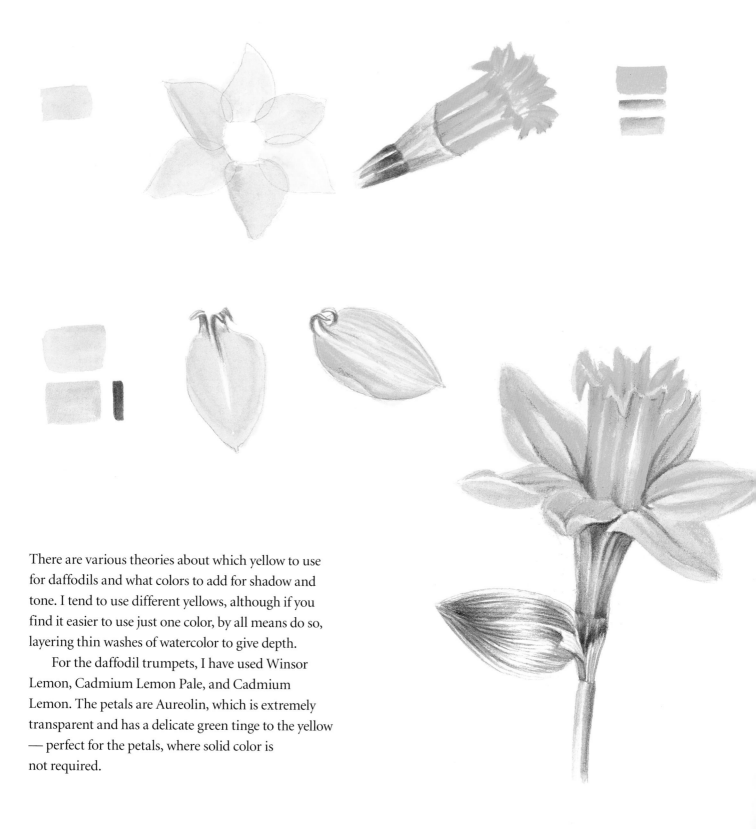

There are various theories about which yellow to use for daffodils and what colors to add for shadow and tone. I tend to use different yellows, although if you find it easier to use just one color, by all means do so, layering thin washes of watercolor to give depth.

For the daffodil trumpets, I have used Winsor Lemon, Cadmium Lemon Pale, and Cadmium Lemon. The petals are Aureolin, which is extremely transparent and has a delicate green tinge to the yellow — perfect for the petals, where solid color is not required.

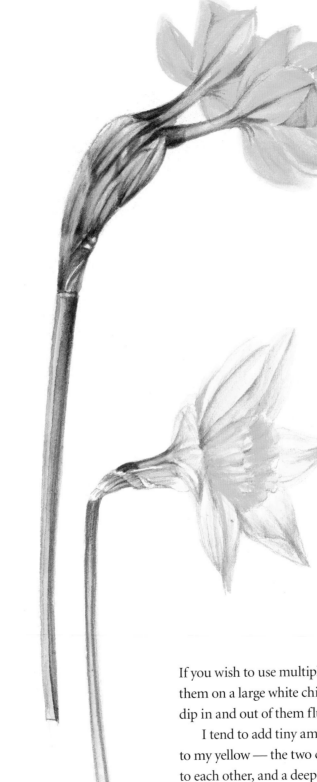

If you wish to use multiple colors, mix pools of them on a large white china plate, so that you can dip in and out of them fluently while you paint.

I tend to add tiny amounts of Winsor Violet to my yellow — the two colors are sympathetic to each other, and a deeper tone of the base color results rather than a muddy yellow. For green-yellow tones, I add a little Ultramarine. The quantity of these colors should be minuscule, so practice first before applying.

Bouquet of daffodils

Daffodils are often sold in bunches in bud form and very quickly emerge into the full flower. I find the straight stems attractive when they are tightly packed in this way, so I put them in a tall, slender vase and waited for the flowers to bloom. For my final study, I liked the idea of tying them with some ribbon to break up the upright angularity of the stems.

I drew the heads of the daffodils on tracing paper first, since I wanted to achieve a semicircle effect, which meant adjusting some of the stem lengths.

Once I was happy with my drawing, I transferred the image to my watercolor paper with my light box — if you do not have one, you can use a well-lit window (see p. 96). I then painted the daffodil heads with very pale washes to achieve the general structure of my painting.

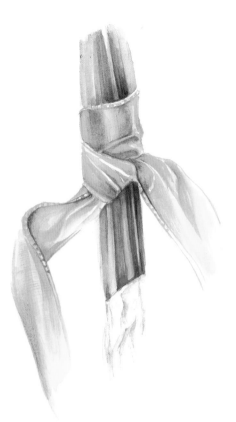

I painted a separate study of a ribbon around
the stems to practice where depth of color was
needed and where the lightest areas should be left
to achieve shine and movement.

For the final image, I added touches of Winsor Violet to both the
Aureolin for the petal shadow areas and to the other yellows for
the trumpets. I built up the depth of color on the flowers with
Cadmium Yellow, particularly on the trumpets.

I needed a blue-green mix for my stems and created
this with Ultramarine and Cadmium Lemon Pale. I used
a more intense green where one stem butted up against
another and added several layers of watercolor to create
depth of color. Some parts of the stems were visible
between the heads of the daffodils, and to paint these,
I had to make sure they linked up with the stems
visible below the flowers. It is important to get this
right to ensure that your final image is convincing.

Painting white flowers

When you paint white flowers, form is everything — every little dip and curve must be emphasized to provide a reason to add shadow and give your flowers depth. At first, use the paint sparingly, then darken it slowly as you work over the flower. Do not finish one petal at a time, but work over the whole area. Once the groundwork has been done, it will be easier to see the form of the flower and decide which areas you wish to add more shadow to. Remember, you can always go darker, but it will be difficult to go lighter.

Practice mixing some colors to make your shadow color. For pure white flowers, use a blue-gray and try adding a touch of Cobalt Blue behind a petal as it makes the white of the flower whiter. With a cream-colored flower, you will need warmer shadow areas — your mix should resemble very weak tea. After applying a clear wash of water to your image, apply a small amount of shadow, give your brush a good rinse, dab off the excess moisture, and wash the color out to the white of the paper. Below are some suggestions for practicing shadow mixes.

Winsor Yellow **Burnt Umber** **Neutral Tint**

Alizarin Crimson **Ultra-marine** **Winsor Yellow**

Cobalt Blue **Burnt Sienna**

Cadmium Red **Cobalt Blue**

Terre Verte **Winsor Violet**

Light Red **Cobalt Blue**

White anemones

Here, I have shown anemone flowers at different stages of development. The shadow mix used is Terre Verte with Winsor Violet. To this, I have added small amounts of Magenta to achieve the pinkish-gray color that appears in some of the shadow areas.

Here, you can see my practice petals and the center of the flower. For the back petals, I used stronger mixes, adding more green to my gray. For the green stems, I mixed Ultramarine and Winsor Lemon. The stamens are Cadmium Yellow. A useful tip is to draw these first with a sharp 6H pencil, since this will give them a gray edge without it appearing too dark.

Camellia japonica

For the camellia flowers, I mixed a gray from Light Red and Cobalt Blue, erring on the side of a bluer shade. I drew the flowers and then applied a clear wash of water. Once the paper was dry, I worked over the whole flower and then darkened it where necessary. I added small amounts of Raw Sienna as the color of the stamens cast a yellowish shadow in parts.

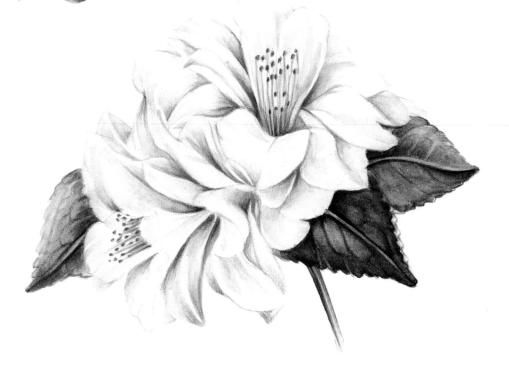

Allium tuberosum

Allium tuberosum, commonly called Chinese chives, has a strong onion scent. It is a very pretty plant with its small star-shaped flowers.

In my practice pieces, I added tiny amounts of my gray mix of Cobalt Blue and Light Red, where one petal overlapped another and other shadow areas. The mix had a greater amount of Cobalt Blue in order to achieve a whiter-looking flower. The stamens are Raw Sienna. For the leaves and stems, I made a blue-green from Ultramarine and Cadmium Yellow, while Terry Harrison Midnight Green gave me the strength of color I needed on the dark side of the stems and the center capsules of the flower heads.

Practice painting individual flower heads first. A No. 2 brush with a good point will give you adequate control when applying your watercolor to the shadow areas. Also illustrated is a small study of the leaves, where I have paid particular attention to the shadow areas where the leaves bend and overlap.

I made a drawing of the allium on tracing paper, cropping the leaves slightly at the side and placing the stems and flowers carefully to create a sense of balance and harmony. The whole drawing was then inked with a waterproof fine pen. When you have small details of a plant to transfer, as here, inking is helpful since the image is more clearly visible through the paper.

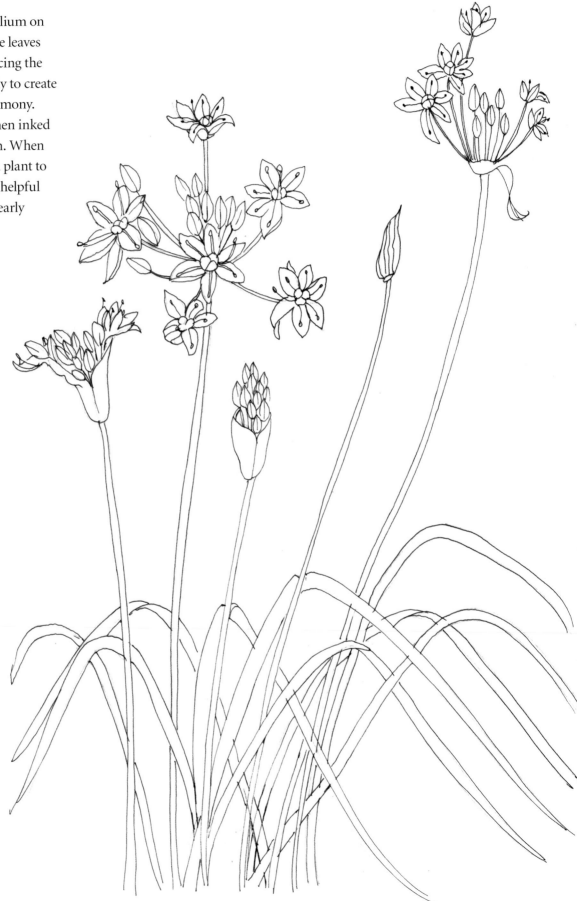

Once the drawing was transferred, I worked on the flower heads, gently adding the gray shadow mix in tiny amounts where one petal overlaps another. I used Midnight Green for the center capsule and a green mix of Ultramarine and Cadmium Lemon for the flower stems, darkening one side with Midnight Green. I described the stamens with small amounts of Raw Sienna. The flower head on the right-hand side was reworked, adding more color to give greater definition where needed, and the green mix used in the practice piece was applied to the leaves.

After putting in my initial gentle washes, I assessed the painting and added more color in areas that needed extra depth, such as the shadow areas on the petals. I reworked the stems using more Midnight Green to the right, leaving the left lighter to create an illusion of roundness. I paid particular attention to the relationships between the stems and leaves, adding darker or lighter washes of watercolor to distinguish where they overlapped each other.

Finally, with a magnifying glass, I worked over the whole piece to crispen any edges that required attention.

Hyacinths

These beautiful, fragrant flowers can be found in shades from the palest blue to a deep blue-purple. The multiplicity of the individual flowers may seem daunting at first, but removing a flower or two and painting separate studies of them to familiarize yourself with the structure will help. In essence, they have quite a simple shape, and by drawing and painting them singly from the front and side, you will have taken into account everything you need to paint them en masse.

I used my tracing paper to experiment with design ideas, some of which were then transferred to my watercolor paper. I particularly liked the way one flower arched over as it faded and chose to paint it alongside one in full flower.

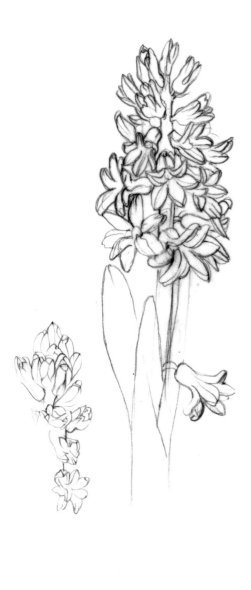

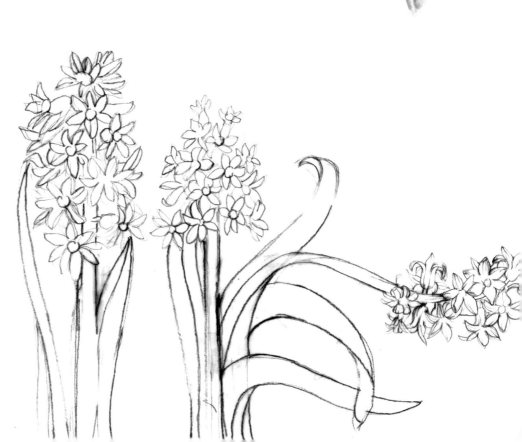

After applying the usual clear wash, I began laying my first washes of color. Daniel Smith's Cobalt Violet was perfect for the petals, varied with touches of Ultramarine and Cobalt Blue. For the reverse of the flowers, I used Cerulean with a touch of Ultramarine. I mixed Midnight Green with Terry Harrison Sunlit Green for the leaves and added some Winsor Violet to this for the stems, giving me a deep violet-green color.

For the darker blue-purple hyacinth I added on the right, my color mixes remained mainly the same, but this time I added more Winsor Violet, particularly to the buds at the rear of the flower head.

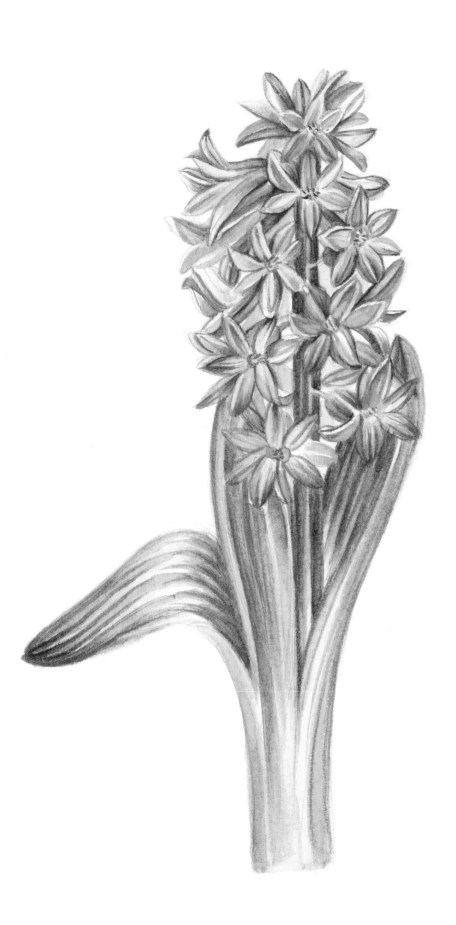

Here, a separate stem of the hyacinth is shown along with a partially worked stem, demonstrating how you should start applying the watercolor.

Iris reticulata

This is a dwarf bulbous perennial, reaching only 6 inches (15 cm) in height. It has sturdy, narrow leaves, and the flowers are blue-purple and deep violet with a central deep yellow ridge. I have painted the plants in various stages of growth — even the one showing signs of decay was a fascinating subject.

For the flowers, I used Daniel Smith's Cobalt Blue Violet, strengthening it in areas with Winsor Violet. The yellow in the center had to be strong, so for this I chose Cadmium Yellow; the blue-green leaves were made up with Ultramarine and Cadmium Lemon Pale. The hue of the enfolding papery sheath can be achieved by using the colors within the flower, taking small amounts of Winsor Violet and adding the green mix in very dilute form to create a transparent wash of color.

Iris reticulata can be found in many variations of color and it is worth looking for some of the paler blue and very deep purple cultivars.

Roses: peach and pink

I received a beautiful bouquet of flowers that contained two peach-colored roses and two pale pink, a wonderful subject to paint. The color of the peach rose was so pale that I had to resort to mixing several different colors to achieve a match. For a pale pink, I decided on Holbein Shell Pink, to which I added a touch of Lemon Yellow. I varied the colors by adding Naples Yellow for the more creamy petals and some Holbein Permanent Yellow Orange, a bright, clear orange, which was noticeable where the petals overlapped. For shadow areas, I added a touch of pale yellow-green, made from Cerulean Blue and Lemon Yellow, since this tinged the lower petals.

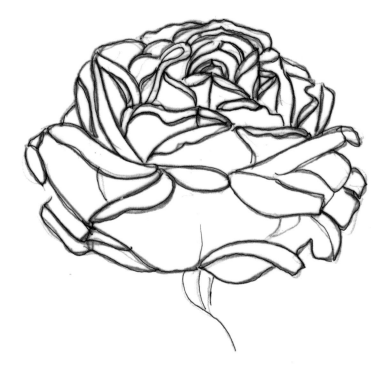

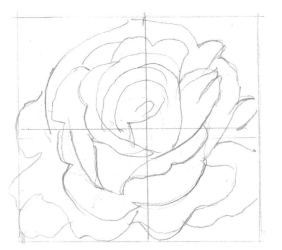

If you are unsure about getting the initial drawing right, start with a box the width and height of the rose. Accurate botanical paintings should be the same size as the subjects, so getting the right size is a good skill to practice. Divide the box into quarters. I tend to work from the bottom up when drawing roses, since the center of the rose shown at the top becomes tightly packed, and a very fine brush will be needed for the detail.

Because of the very pale color of the pink rose, it was important to remove as much pencil from the drawing as possible before applying the paint. I started with the palest of washes of Permanent Rose over each of the overlapping petals and built up layers of the same color to give depth.

For the leaves and stem, I used Terry Harrison Midnight Green, mixed with Sunlit Green. By combining these two colors, I could create variations from the palest to the darkest green.

Rudbeckia

The colors of this rudbeckia make it one of my favorites, with deep golds through to rusty browns. I applied a pale wash of Quinacridone Gold to all the petals, leaving lighter areas where they arched and putting in deeper tones toward the center and where they overlapped. I then added varying amounts of Burnt Sienna and Burnt Umber, mixing some Indanthrene Blue into the latter where I needed depth of color. I washed small amounts of Permanent Mauve on the undersurface of the petals to indicate the change of color. The center was an intense brown over gold, applied as small hairs.

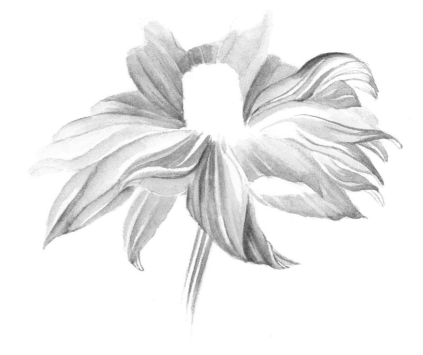

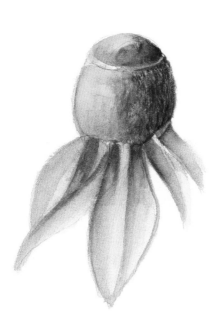

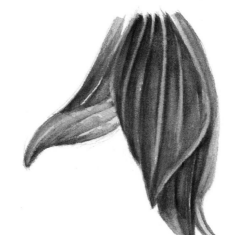

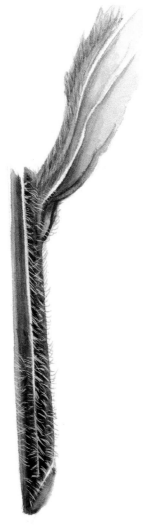

The stem and leaves are hairy, and after establishing the color using Ultramarine Blue and Lemon Yellow and applying layers for intensity of color I added a reddish-brown mixed from Burnt Umber and Alizarin Crimson to the bottom half of the stem. I applied a stronger green color from the same blue and yellow mix to the right-hand side of the stem in order to create an illusion of roundness. It is a good idea to go a lot darker before adding hairs since they will show up more; hairs on a pale stem or leaf will not show up at all.

If you do not feel confident about applying hairs, practice this before embarking on the painting; adding hairs is usually the final step, so there is no margin for error. Study the angle and distribution of the hairs carefully — they will obviously vary between plant species. Use white gouache and a brush with a good point. It is not always necessary to work with a small brush — a size 3 or 4 will hold a good amount of paint, rather than a smaller brush that you will have to keep dipping. It is best to try both and find out which you prefer.

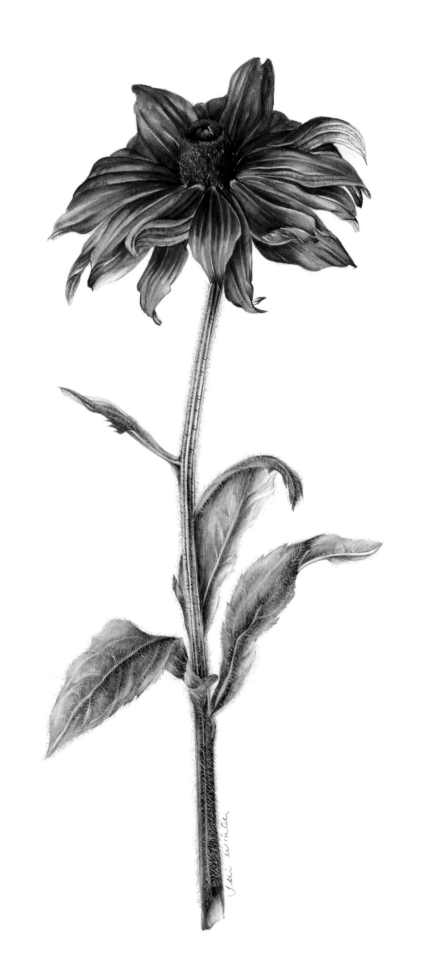

Sunflower

I painted this sunflower head using the same watercolor palette as the rudbeckia on pp. 82–83. Once again, I used gouache for the hairy stem, but this time I dry-brushed the hairs on, to create a soft appearance. The leaves are left loose, fading away into the paper.

This particular sunflower caught my eye because of its dark russet-colored petals, very different from the usual yellow varieties. Sunflowers keep remarkably well once cut, allowing you plenty of time to study them before starting your work. For this piece, I positioned the flower side-on so as to partially show the back of the flower head.

Digitalis × mertonensis

Foxgloves come in many different forms, and a favorite of mine is *Digitalis × mertonensis*. The flowers are a soft pink color and the flowering period quite extensive, from early to midsummer. Sometimes the way a plant grows can give you a natural composition. I was attracted by the way these stems arched and decided to paint one with a combination of flowers and seed pods.

Before painting the whole plant, I made some practice pieces. I mixed a very small amount of Naples Yellow, an opaque pigment, with Permanent Rose to achieve the density I needed for the slightly chalky pink petals of this foxglove. For the darkest parts, I added a small amount of Sap Green, enabling me to achieve a dark rose color. The internal dark pink markings were made with a mixture of Alizarin Crimson and Indigo. I touched in a stronger mix of Naples Yellow at the edges of the flower.

Finally, I put in the hairs with a No. 1 brush and a strong mix of white gouache in delicate strokes. I then applied my main color mix behind the hairs to give them a sense of shadow and definition. Those that protruded from the edge of the flowers were achieved with a 2H pencil, sharpened to a fine point.

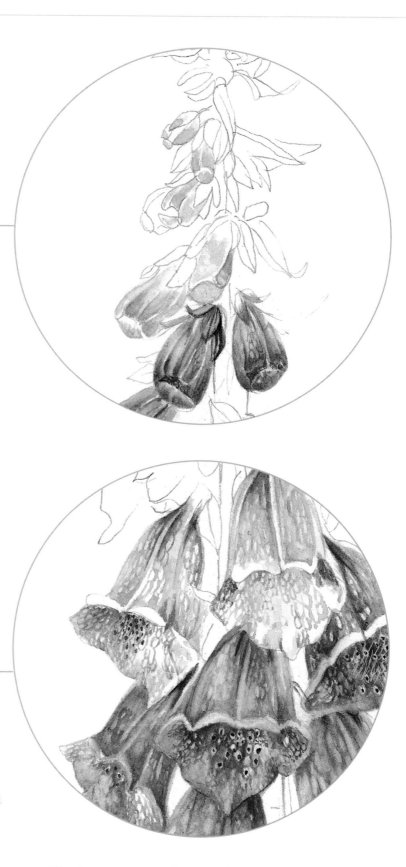

The flower stem was drawn with a pencil and color applied to the petals and buds in this preparatory stage. With a detailed, complex plant like this, you will need to be patient and methodical, referring back to your practice drawings.

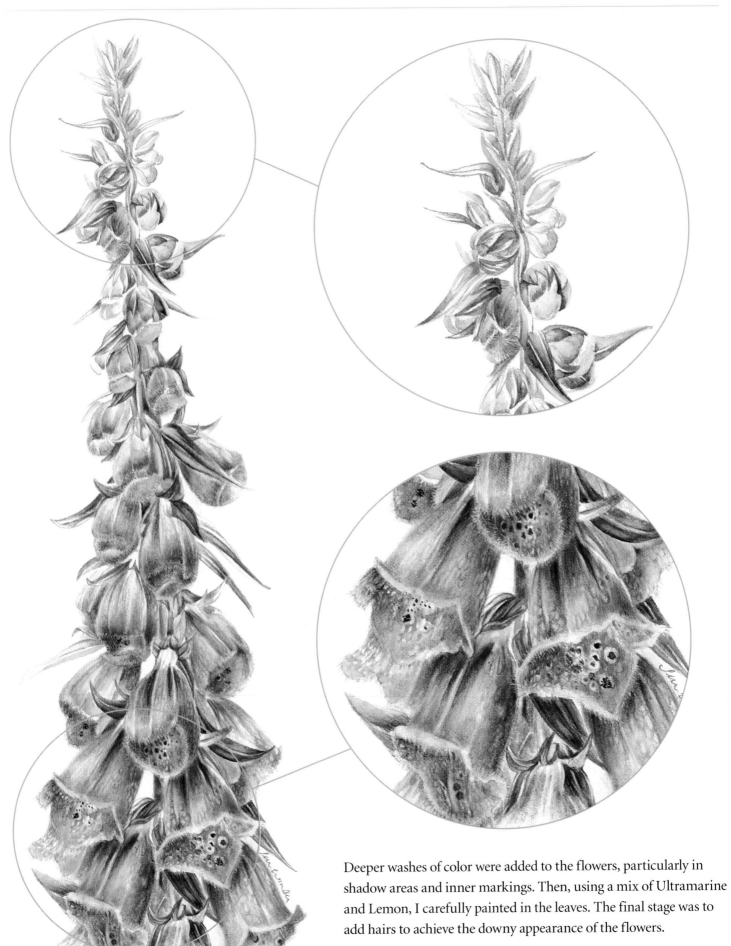

Deeper washes of color were added to the flowers, particularly in shadow areas and inner markings. Then, using a mix of Ultramarine and Lemon, I carefully painted in the leaves. The final stage was to add hairs to achieve the downy appearance of the flowers.

Medinilla magnifica

This truly beautiful plant was a gift from my art group. It was presented to me in the winter when the weather was icy cold, and I was apprehensive about whether I could keep it alive. I put it in a warm spot, and it surprised me by lasting for about six months, which gave me plenty of time to study it.

As the plant was quite large, I had to consider the composition and how to place all of it on the paper. I decided to draw it in two parts and placed one set of the flower heads to the side of the main plant and leaves.

When figuring out a composition for a large plant such as this one, I recommend making individual drawings of different parts of the plant on tracing paper. These can be cut out and moved around to create a pleasing composition.

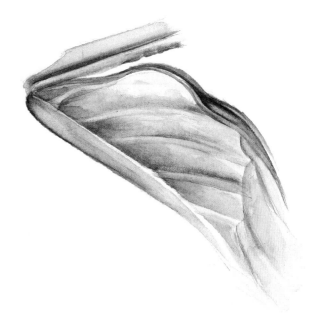

Working around the drawing, I applied a very pale pink watercolor wash to the flowers, leaving highlights as I went. The green of the leaves was a mixture of Terry Harrison Midnight Green and Sunlit Green, with additions of Cerulean and Cobalt Blue.

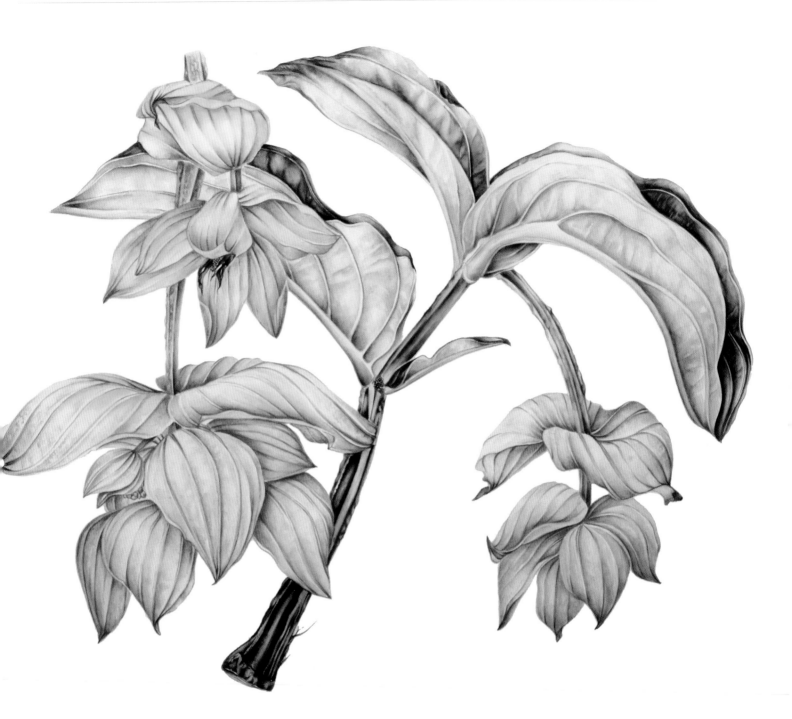

The stem is a very dark green. For this, I used a mix of Quinacridone Gold and Winsor Green Blue shade, with an addition of Winsor Red to darken down the color.

As the tips of the petals were tinged with green-gold, I dropped in some Sunlit Green and Quinacridone Gold. I also found that mixing the gold with the green and applying that over the veins intensified the color perfectly.

This painting has always held a special place in my collection, not only because of the nature of the gift but also because it won the Daler-Rowney choice award at the UK's Society of Botanical Artists exhibition.

Shiny berries and hips

Many species bear fruit that is very attractive, giving the plant a longer period of interest in the garden. The fruit is often shiny, giving the botanical painter a chance to portray a very different surface from that of flowers and leaves.

Arum maculatum

The cuckoo plant is highly poisonous but very beautiful, with red to orange berries that appear in the fall after the leaves and spathe have withered. Here, I have painted three stems in order to practice the shine on the berries. I particularly like the stems where there are a few green berries dotted among the vibrant orange and red ones.

Practice leaving white to create shine by applying small amounts of color and gently softening the color into the white of the paper — too much water, and the white will be flooded with color. Using a dry brush technique is the ideal here.

Add Winsor Red to Holbein Permanent Yellow Orange for the deeper color where one berry overlaps another up the stem. The stems are long and straight; add a touch of mauve at the bottom to create an almost bruised effect.

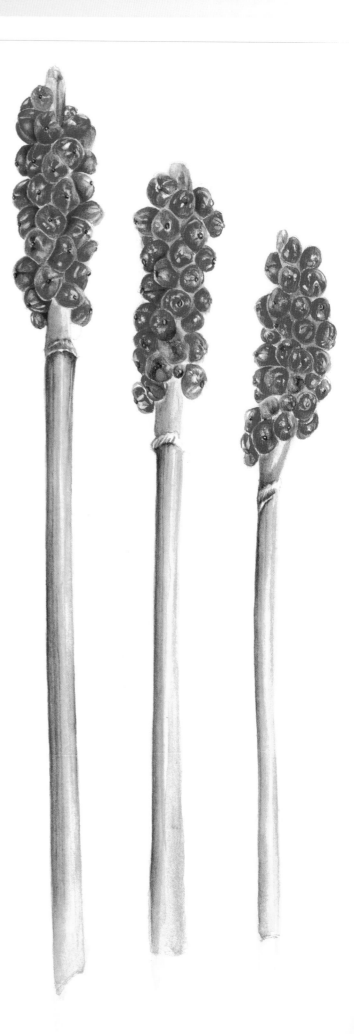

Iris foetidissima seed heads and berries

Iris foetidissima flowers are a pale lilac-yellow and could easily be overlooked in a garden. However, the berries that form later are a striking deep yellow-orange color inside fat green pods. The plant is commonly called "stinking iris" because of the odor emitted when the leaves are crushed. Again, this is a highly poisonous plant.

Use the same colors as the arum berries, leaving highlighted areas as before. Apply your color, and gently move the paint into the highlighted area with a slightly damp or dry brush. I have interspersed the red-orange berries with a few black ones.

Rosa rugosa hips

Practice by first applying a thin wash of color after your initial preparation work. Working around the highlighted areas, add more washes, gradually building up your color.

Deepen the color of your red by using a touch of Alizarin Crimson, or try adding a small amount of Ultramarine and Cadmium Yellow mix to the red; this will make a nice shadow color for the bottom of the hips.

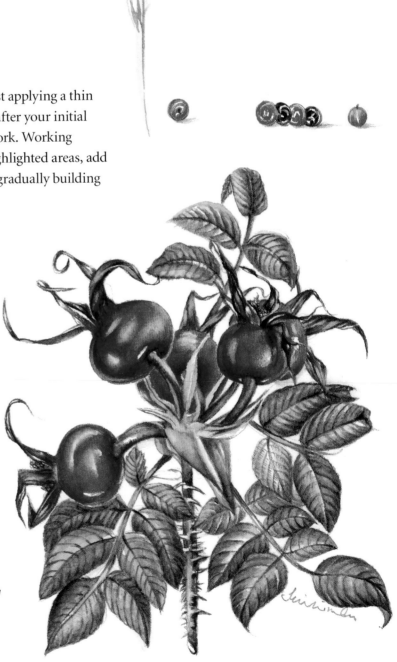

**A thorny stem of *Rosa rugosa*
hips and leaves**

Chapter 5

DIFFERENT PAINTING TECHNIQUES

In this chapter, we will look at different techniques that you can experiment with to depict your flowers. Staying with watercolor, you will discover a looser style of painting known as wet-into-wet, which can also be combined with an outline in waterproof ink. Then we shall explore in depth the versatility of colored pencils, from watercolor pencils to oil- and wax-based pencils blended with oil rather than water.

I will show you how to set a flower composition on a colored background, and we will look at the exciting possibilities of using a printing press to create an image and making a plate on which to etch an image.

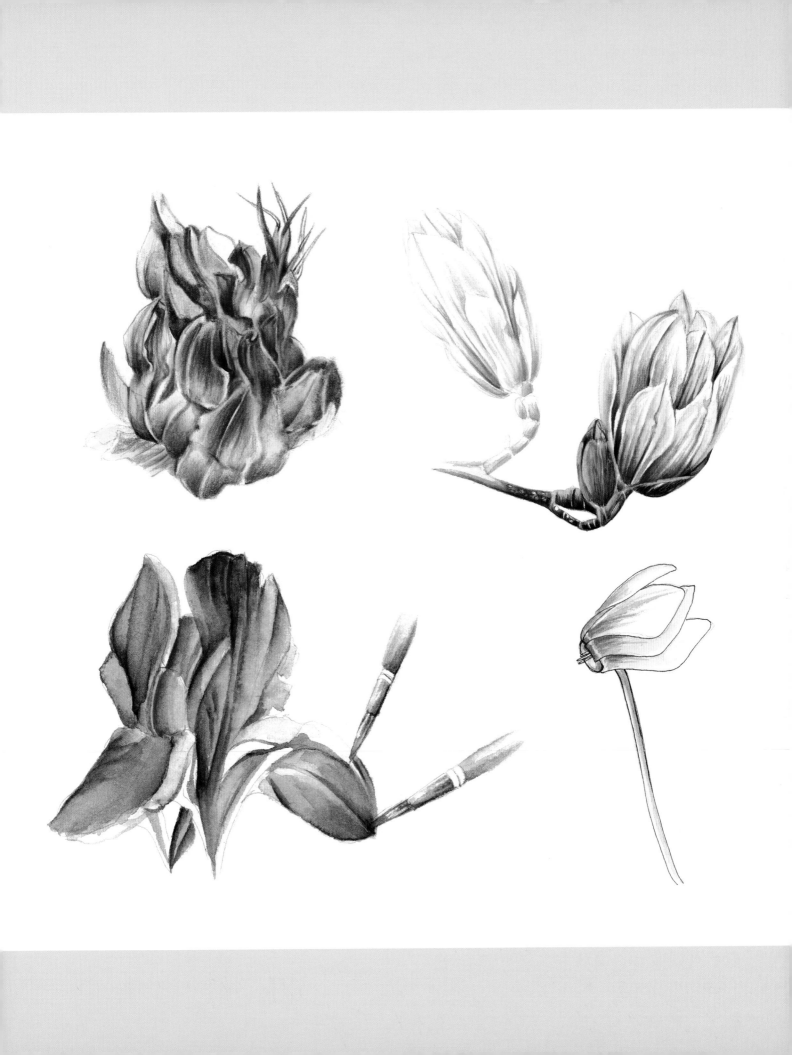

Pen and watercolor: cyclamen

Bear in mind when you attempt this technique, that the ink pen you use must contain a waterproof ink, or else when you add watercolor the ink from the pen will seep into the paint.

For this exercise, I used a cyclamen plant and first drew individual studies of the flower heads using an HB pencil. With a fine 0.05 mm waterproof ink pen, I retraced the graphite line. Then I added a fine layer of Permanent Rose watercolor to the petal, taking care to achieve a smooth watercolor wash, nothing too heavy.

To color the stem, I mixed Sap Green with the Permanent Rose I had used for the petals. The color of a stem is often found by mixing together greens with the color from the flower.

I suggest practice pieces of the flower head, stem, and calyx before embarking on your final piece.

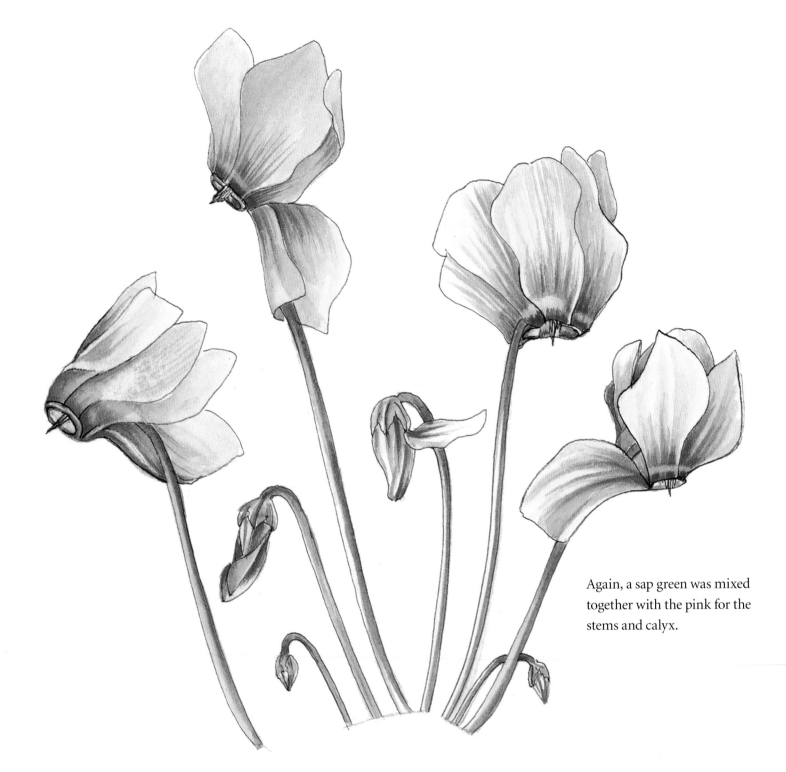

Again, a sap green was mixed together with the pink for the stems and calyx.

For the final composition, I drew several stems and flower heads, first with pencil, then with waterproof ink. I added layers of watercolor to the petals, taking care to start at the base of the flower head and pull the watercolor out toward the edge of the petal. Further layers of fine watercolor were added to the base of the petal since the color was deeper at this point.

Foxgloves in pen and watercolor

Digitalis "Serendipity" must be one of the most stunning foxgloves I have ever grown. It is unusual in that it has split petals, giving an appearance somewhat like an orchid — hence the name of orchid foxglove.

The drawing is quite complex, and for this reason, I worked it on tracing paper first to make sure I had been accurate. Tracing paper is ideal because you can erase your mistakes as many times as you like, avoiding the risk of destroying the surface of your watercolor paper by using an eraser, particularly if it is Hot Press. This is particularly important for an ink drawing because a flat, smooth surface is required for a smooth, unbroken line.

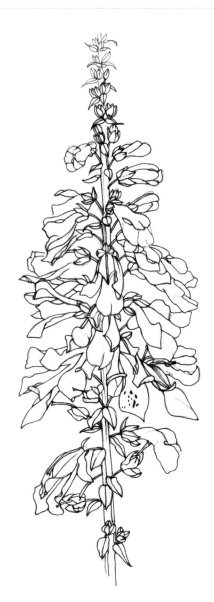

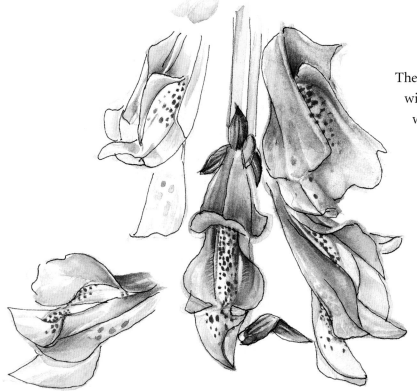

The drawing was then transferred to my Hot Press paper with an HB pencil. To do this, I taped the tracing paper with the image against a window and put my paper over the top, so that the image showed through, a handy method for images too large for my light box. I then went over the drawing with a Rotring 0.25 mm waterproof pen.

Once my outline drawing was ready, I applied a soft, diluted Quinacridone Magenta pink loosely to the petals, then green tones to the top buds. My green was made up using Ultramarine and Aureolin, and this same color mix was also suitable for the leaves and stem. It is always a good idea to make smaller practice pieces before embarking on the final artwork.

After I had completed the watercolor I reapplied the waterproof ink where I felt the line needed to be stronger and also made the markings on the inside petals. I omitted the hairs that would normally appear on the petals and stems because the black pen would be too dark for those, and they were also unnecessary for this style of painting.

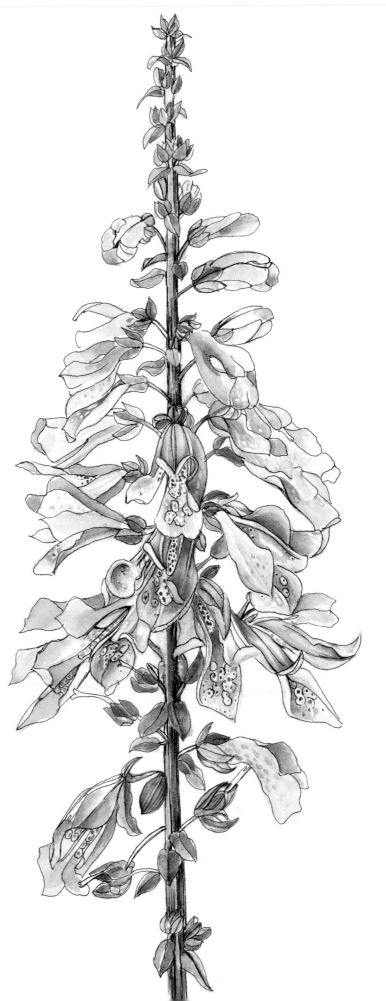

Painting wet-into-wet: iris

We touched on this technique on p. 54, and here, I show how it can be used to create a full flower painting. A lot more water is needed when painting in this style, and I used a much heavier paper than usual 400 lb (850 gsm), since a lighter weight would cockle (warp) unless it was stretched first by wetting it and taping it firmly to a board. With very thick paper, you can skip this preparatory stage. A larger sable brush, still with a good point, is needed, for example, a No. 5 or 6.

Dot the colors from the tubes that you will use around a white china plate, and make pools of color in the center. For this iris, I used blues, purples, reds, and violet colors. Refer back to your color wheel to see potential color mixes.

Before starting on the painting, experiment with letting your colors run together. Wet an oblong section of the paper thoroughly with clear water — you will need quite a lot on a thick paper. While the paper is still damp (not wet), drop in your watercolors and watch how they merge together. A good tip to assess if your clear wash is still too wet on the paper is to offer the paper to the light; if there is a considerable sheen remaining, it is still wet — and if there is no sheen at all, it is now too dry. The ideal state is when it has a slight sheen to it.

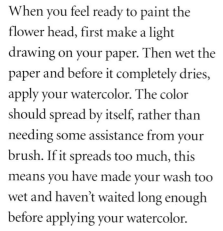

When you feel ready to paint the flower head, first make a light drawing on your paper. Then wet the paper and before it completely dries, apply your watercolor. The color should spread by itself, rather than needing some assistance from your brush. If it spreads too much, this means you have made your wash too wet and haven't waited long enough before applying your watercolor.

While the paint is still wet, you can start to add in your other color. You will find you need to apply quite a lot of paint, as the paper absorbs the watercolor very quickly, and it dries a lot lighter than when it is first applied.

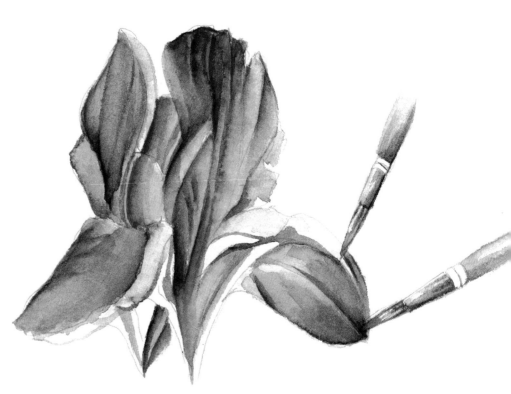

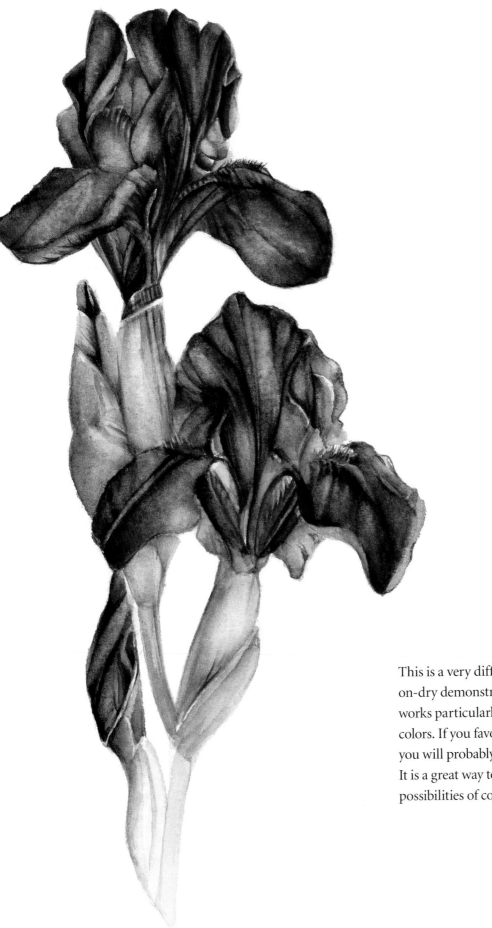

This is a very different technique from the wet-on-dry demonstrated so far in the book, and it works particularly well for an iris with its many colors. If you favor a looser style of painting, you will probably enjoy working wet-into-wet. It is a great way to experiment with the many possibilities of color relationships.

Underpainting with gray: magnolia

Sometimes I use gray to underpaint a flower, particularly when the flower has partially white petals and a dominant gray element. I find the magnolia particularly suited to this method of painting, since the pink in the petals has a lot of blue-gray undertones and painting with the grey first eliminates my having to go through various color mixes to achieve the muted color required.

Generally, I use Light Red and Cobalt Blue for my gray mix, adding a touch of Quinacridone Magenta to give the pink tones of the magnolia.

After drawing the bud (left) and preparing the paper, I painted the bud with my gray mix. The second bud was painted in the same way but with a wash of Quinacridone Magenta laid over it.

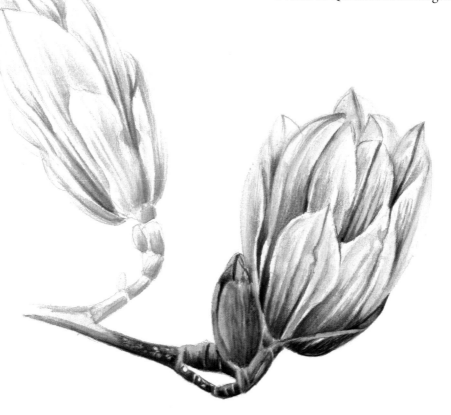

The branch of magnolia buds is shown along with a dead flower that had taken on beautiful soft yellow-browns and mauves. For the stem, I have used Burnt Umber, with the addition of Indigo to create depth of color. The hairy capsule is painted in Schmincke Green Earth, with the hairs dry-brushed on afterward when the underlying paint was dry, using white gouache for its thicker texture.

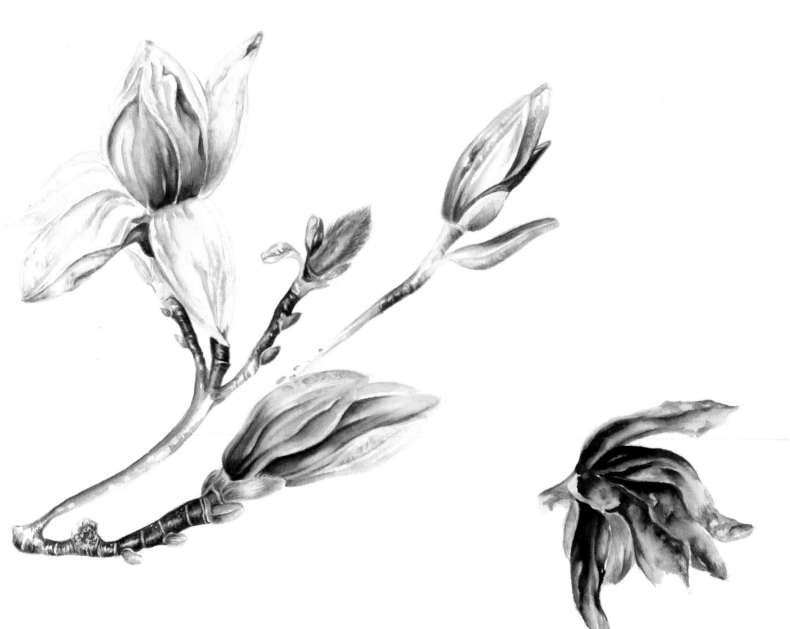

Colored pencils

For many people, colored pencils are a more friendly medium than watercolor. Perhaps this is because most of us used crayons when we were children, so they feel familiar. Now, though, we can refine their use to achieve a more professional look.

The range of colored pencils on the market today is wide, with most of them colorfast and suitable for exhibition work, particularly the Faber-Castell Polychromos range used for the illustrations shown here. The best paper to work with is Hot Press, as a smooth working surface is necessary to achieve a steady line.

Always make sure your pencils are sharp — you may have to do quite a lot of sharpening as you work, so have a pencil sharpener to hand. Never use a blunt pencil, since you won't be able to achieve the definition you need. I used to work with a desktop pencil sharpener but wasted so much pencil as a result of the lead getting jammed that I resorted to a handheld sharpener, which does the job efficiently. Work in your color with small circular movements to achieve a continuous, even tone.

Blending with oil: artichoke seed head

For the artichoke seed head I have used Faber-Castell Polychromos and Prismacolor Soft Core pencils, which are oil-based and wax-based respectively and work well together. First, I drew the seed head in HB pencil, and then, working from the bottom up, I started to apply my lightest color.

Caput Mortuum

Burnt Cherry

Burnt Ocher

Next, going back to each section, I added darker colors, blending them each time with baby oil. There are several ways of doing this. I sometimes use a double-ended Empty Marker Pen made by Copic, filled with a small amount of baby oil. This pen has a broad, chiseled end and a small pointed one for finer details. You can also use a cotton bud or drawing stump (tortillon), gently dipped into your baby oil. The oil acts in the same way as water does with a watercolor pencil (see p. 110) in that it softens, blends, and spreads the color, eliminating any residual lines or grain of the paper.

Colorless blender pencils give a similar result — they do not spread the color as much but are useful for a more controlled effect. Splender Blender, made by Lyra, is readily available, and Prismacolor offer a blender with a softer core.

I drew the purple hairs on the artichoke individually using ranges of purple and blue pencils, but I did not blend these with oil because a strong, fine line was needed.

Brown Ocher

Blue Violet

Dahlia Purple

Wax-based colored pencils: "Black Parrot" tulip

For the parrot tulip heads shown here, I have used Prismacolor Soft Core wax-based pencils. Although they come in a wonderful range of colors, they are a very soft pencil and therefore it is difficult to achieve crisp edges; where I need those, I use a Faber-Castell Polychromos (oil-based pencil) as it is a much harder pencil.

For simplicity, I have used just three colors to depict this flower head and two for the stem, since a small palette will enable you to practice the technique without the added complication of coping with a multitude of colors.

After drawing my flower head, I applied Black Cherry in the darkest sections of the flower. Using the broad chisel end of a Copic Empty Marker Pen filled with baby oil, I spread the color with clean sweeps across the petals. Alternatively, you could use a cotton bud to spread the color.

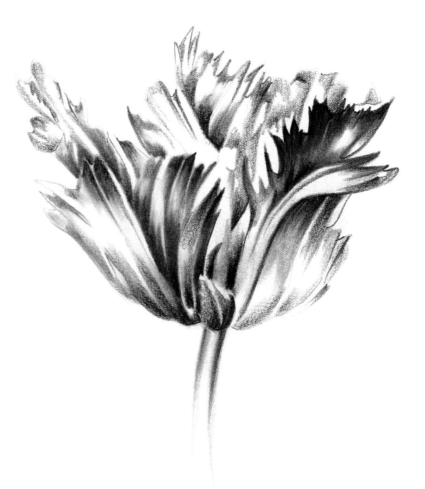

Cold Cherry

Black Cherry

Magenta

Black Grape

May Green

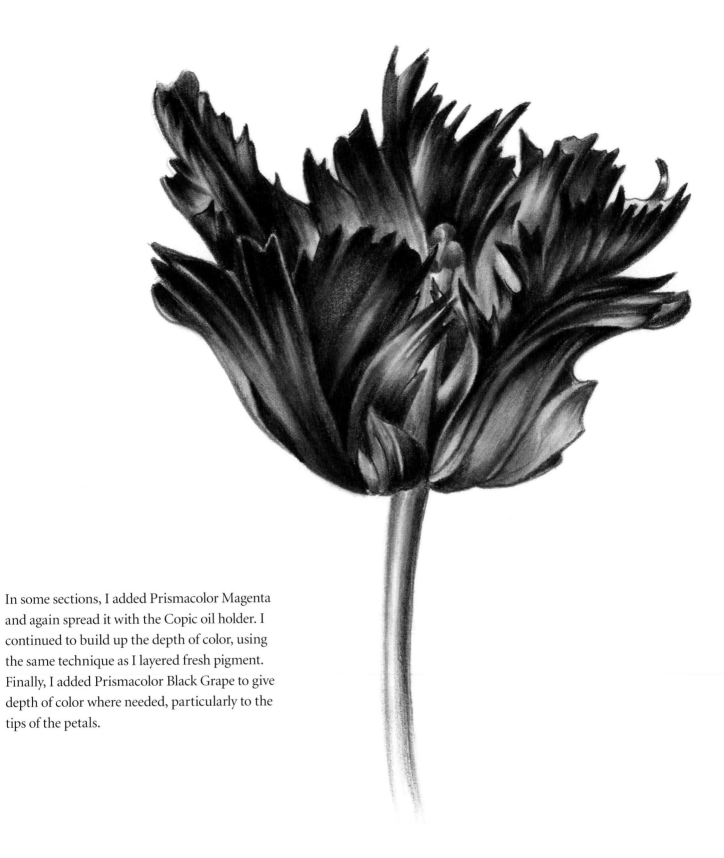

In some sections, I added Prismacolor Magenta and again spread it with the Copic oil holder. I continued to build up the depth of color, using the same technique as I layered fresh pigment. Finally, I added Prismacolor Black Grape to give depth of color where needed, particularly to the tips of the petals.

Oil-based colored pencils: Calla lily

Since Polychromos colored pencils are oil-based, they cannot be used with water. For this calla lily, I have used a clear blender pencil and a Polychromos Ivory for blending. The blender pencil softens and enhances the color, while the Ivory adds a soft cream-colored hue to the flower.

In contrast to the "Black Parrot" tulip, this calla lily has many colors — dark red, burnt sienna, golds, and greens. I have used a warm gray underneath the red to enhance the dark red colors that appear at the center and edges of the flower.

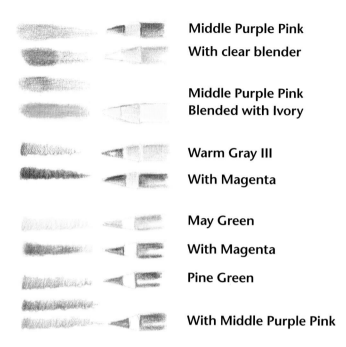

Middle Purple Pink

With clear blender

Middle Purple Pink Blended with Ivory

Warm Gray III

With Magenta

May Green

With Magenta

Pine Green

With Middle Purple Pink

I drew the calla lily in pencil, then rolled a putty eraser over it to remove any heavy lines that would show through the colored pencil work. First, I applied Warm Gray III to the top half of the flower head, which is a useful way of deepening the color. I applied Magenta over this and merged the colors with a blender pencil. Next, I added Middle Purple Pink toward the center and May Green on the stem, remembering to leave one side lighter to create a three-dimensional effect.

The Ivory pencil can act as a resist as well as a blender. I drew in the veining with an Ivory pencil, and when I applied May Green over the top, the veins still remained visible. If you are a little nervous about tackling long lines such as these, draw them in small sections and join them up.

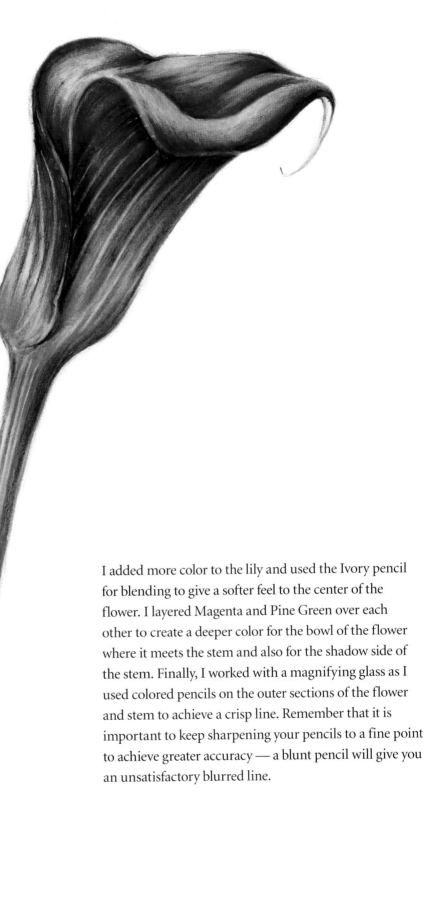

I added more color to the lily and used the Ivory pencil for blending to give a softer feel to the center of the flower. I layered Magenta and Pine Green over each other to create a deeper color for the bowl of the flower where it meets the stem and also for the shadow side of the stem. Finally, I worked with a magnifying glass as I used colored pencils on the outer sections of the flower and stem to achieve a crisp line. Remember that it is important to keep sharpening your pencils to a fine point to achieve greater accuracy — a blunt pencil will give you an unsatisfactory blurred line.

Oil-based colored pencils: "Duchesse de Nemours" peony

I treated this white flower with added tones of cream in the same way as I paint white flowers with watercolor, using shadow tones where one petal overlaps another. I used Polychromos colored pencils, with cold grays, greens, Brown Ocher, and the addition of mauve in the darkest areas. A touch of mauve blends nicely with the gray-green color to enhance the creamy white of the flowers. When I had placed all the shadows on the petals, I used Polychromos Ivory, as this not only added a cream tone to the flower head but also blended the colors together.

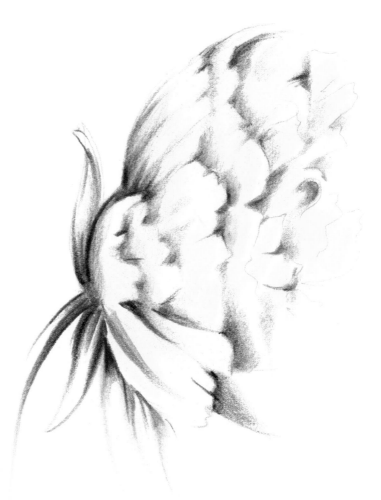

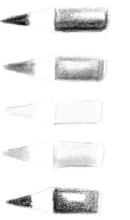

Chrome Oxide Green Fiery

Brown Ocher

Ivory

Earth Green

Dark Indigo

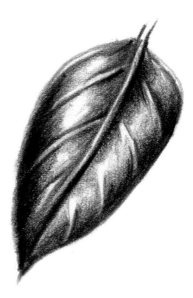

Watercolor pencils

In contrast to the combination of Polychromos and Prismacolor pencils used for the artichoke seed head on p. 102, for these seed heads, I have used Faber-Castell Albrecht Dürer watercolor pencils. These can be blended with water or used with a dry blending method.

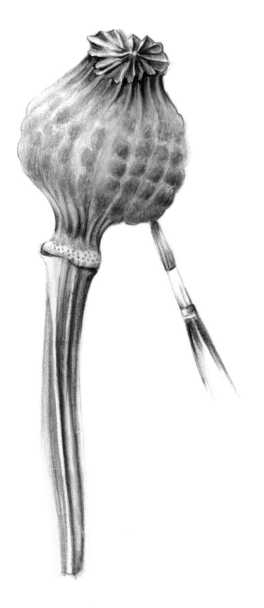

Warm Gray II

Dark Naples Ocher

Earth Green

Bister

Brown Ocher

Dark Sepia

Mauve

Ultramarine

The first seed head shows how the addition of water blends the colors. Compare the left-hand side of the seed head (unblended) and the right-hand side where water has been used on top of the pencils to blend the colors. You will notice how much stronger the color is once the water is applied.

The pencils hold quite a lot of color, and when you add water, you may be surprised by how far the color will spread. Before embarking on a painting, it is advisable to experiment with small amounts of water to see the effects you obtain. A heavy application of the pencil will produce a lot of color when water is added, while a lighter application is more controllable.

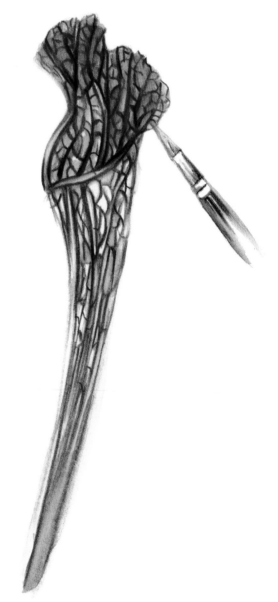

With the second poppy seed head, I applied small amounts of color and then, using a damp brush, softened the color and moved it over the seed head. I then added more color for the shadow areas and to define the top of the poppy, again softening it with water.

May Green

Red Violet

Light Magenta

Madder

The third illustration is of the lovely saracemia. I used greens with dark reds to achieve the brown colors in the bottom half of the plant, then added small amounts of water.

Bister

Walnut Brown

Mauve

Dark Sepia

Raw Umber

Watercolor pencil: iris

I cut an iris stem and placed it in water. I knew the petals would not last long and might even deteriorate over the course of a day, so I needed to work on this quite fast.

I drew a fairly loose study of the iris on Hot Press paper and applied watercolor pencils in blues and violets, most heavily in the darkest areas. With my damp brush, I applied water to the colors and moved them across the paper into the lightest areas.

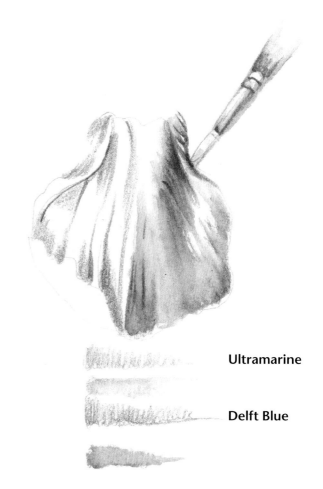

Ultramarine

Delft Blue

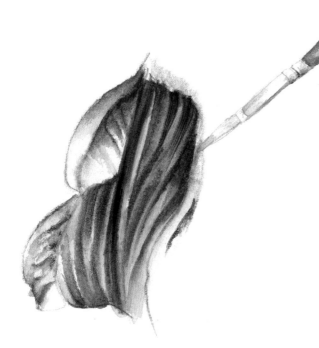

I used richer brown colors on the sheath and again washed them away with a damp brush to preserve transparency.

Delft Blue

Blue Violet

Ultramarine

Burnt Ocher

Bister

Olive Green Yellowish

I added more pencil work where depth of color was needed. I then added greens to the mauve, using the same methods. Finally, with a sharp Blue Violet pencil, I described the thin veining on the petals.

Colored background: sunflower

A background color in a flower painting can be a pleasing alternative to the white paper that is so often used in botanical studies, where the main focus is on the details of the plant. It is a way of making the flower stand forward, which you can do either with strong contrast, as in the tulips (see facing page), or with more subtle colors that complement the color of the subject, such as the sunflower below, where similar but darker colors are used. There are many possibilities with the use of background color, and some may find it challenging to decide which colors to use, where to place them, and how strong or weak they should be.

My preference is for the background color to harmonize with the flower; here, I visualized the sunflower as emerging from the background. I sketched the flower with pencil first, since this would still appear through the surrounding wash of color. I then laid a watercolor wash of yellow-orange, deeper at the top of the paper, becoming more yellow toward the center where the sunflower would be situated, and fading off toward the bottom.

When this was dry, I applied more color to define the petals of the sunflower, then mixed some pinkish reds for the various shadow areas. I felt the sunflower did not stand forward enough from the background color, so to finish I added some dark, almost black, lines with an Albrecht Dürer colored pencil in parts to define the petals.

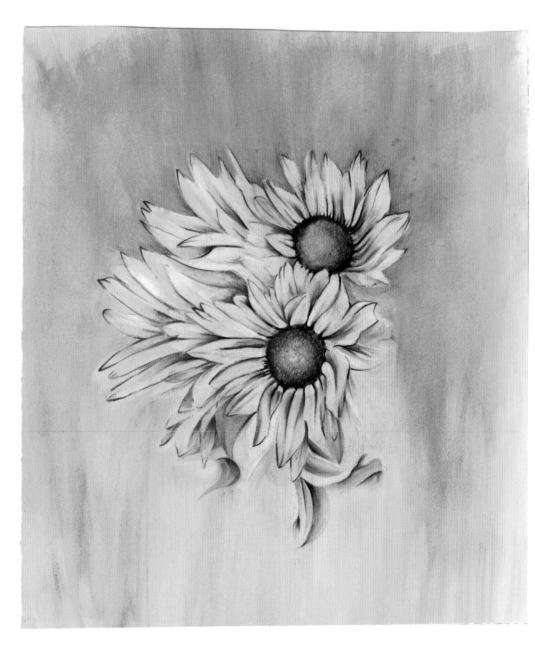

Painting white on a dark background: tulips

A different and interesting technique that produces a striking image is to use white on a dark background. I initially drew the tulips with a white watercolor pencil, then I applied Chinese White watercolor so that the dark background depicts the shadow areas and the white watercolor the main body color.

I have yet to find a colored Hot Press paper, so I have to resort to colored paper in as heavy a weight as possible or even thick cardstock for this technique. The paper absorbs the white watercolor like a sponge, and although it washes out to give a nice effect, you may find you need to apply a heavy mix of the watercolor to achieve a decent depth of color. Color can also be used over the white. There are many possibilities to explore, and this just touches the surface of what can be achieved.

Monotype printing: orchid

This portrait of an orchid employs a very different technique, using printing inks as opposed to watercolors or colored pencils. There is a lot more chance for error, but you will find it an exciting challenge. This technique is called monotype because it produces a single image that cannot be reproduced, unlike most methods of printing. I have described the process very briefly here, though if it is a technique you enjoy, I would recommend further reading, or better still, signing up for a short class.

First, you need to make a plate. Cut a piece of Perspex and bevel the edges with a craft knife. This will achieve a rounded finish to your plate, which will look more attractive when printed than squared edges. Put printing inks in several colors on a white tile, and with brushes and rollers spread the color over your plate.

For this design, I very loosely painted the image of an orchid, then, with a brush, applied blocks of color over the surrounding area, using greens, gray, yellows, and purples that harmonize with the colors in the orchid.

When you have made your own design, put the plate onto a press, painted image facing up, and place damp printing paper over the top of the plate. A plant sprayer filled with water is useful to dampen the paper. I use a paper called Somerset which is ideal for this type of work. Roll the press roller over to transfer the image from the plate onto the paper, and carefully remove the paper when the roller has cleared the paper and plate.

You can ask at an art college or your local art society for use of a printing press, and they are usually more than happy to help. However, you can achieve a monotype print at home using a roller or a rolling pin to roll over the paper. Make sure you press firmly, using extra pressure at the corners of the plate.

Etching: Vanda orchid

Once you are confident in cutting your Perspex plates, you can also use them as etching plates by making lines and marks on them with etching tools (or you can raid the household toolbox).

The image shown here is a Vanda orchid. I used a sepia ink to achieve the color, rolling it over my etching plate before placing that on a printing press.

The advantage of etching over monotype is that you can reproduce a few images from your plate. Because it is Perspex, the marks will deteriorate fairly quickly, unlike a copper plate where the image can be reproduced several hundred times. However, the Perspex is easier to work with because it does not involve the use of acids to create an image.

I made two prints of the image and decided to hand color the petals of one of them. This was done with colored pencils as opposed to watercolor paint.

Perspex plate

Chapter 6

COMPOSITION

In the field of botanical art, it can be tempting to display your image in the center of the paper with no thought to the composition, concentrating entirely on the painting of the plant. Yet composition — the design of your work — is significant since it can take your flower paintings to another level.

There are many options available to you in the search for a pleasing composition. One is to make individual studies on tracing paper, cut them out, and move them around within a frame to find a suitable arrangement. Alternatively, remember that you do not have to include the entire plant. Take a card mount smaller than your plant and place it in front, thereby cropping your image. Before putting pencil to paper, you will know how showing just a part of the study will look on a page.

In this chapter, we will look at paintings that have been composed in various ways.

Traditional botanical presentation: tulip

Greigii tulips have mottled leaves, and their flowers range from cream to deeper colors such as the pink and yellow shown here. I have painted this tulip purely as a botanical study, noting and labeling all parts of the flower, so the composition is arranged with one petal pulled forward to reveal the reproductive parts of the flower head, the emphasis being on information. Individual studies are illustrated at the bottom, which is fairly common with botanical representations of a plant.

Tulipa "Mary Ann"

1. Outer perianth segment (tepal)
2. Inner perianth segment (tepal)
3. Stamen
4. Stigma
5. Style
6. Superior ovary
7. Anther
8. Filament
9. Tepal showing placement of stamen
10. Pedicel
11. Flower with perianth segments (tepals)
12. Cauline leaf
13. Basal leaf
14. Mother bulb
15. Adventitious root

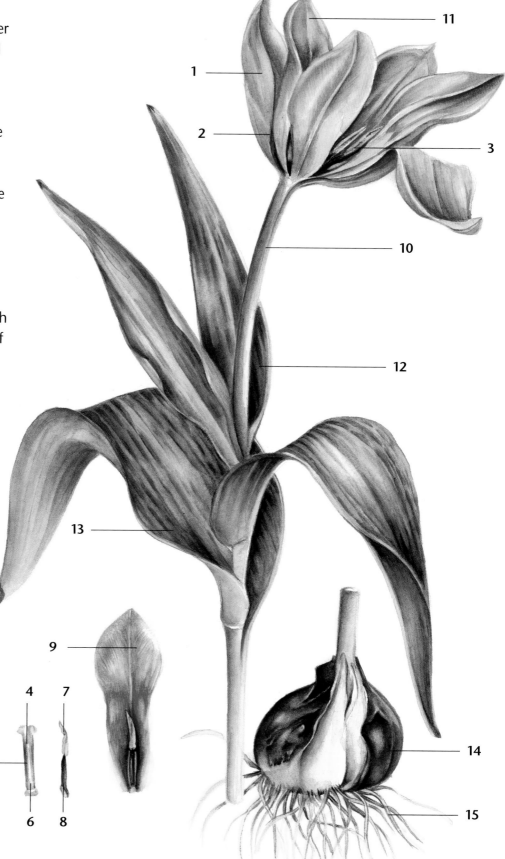

Acanthus

Here is quite a different example of how to present a composition. Acanthus plants, commonly known as bear's breeches, do not respond well to being cut, and the plant had partially drooped, the reason for its arched shape. I found this shape attractive, and fortunately, the plant maintained it as it dried. I drew the shape of the seed head first and then carefully positioned all the dried spiky leaves, seed pods, and dried flowers. The seed head was placed in the middle of the white paper to create a dramatic centerpiece. The negative space (the white of the paper) has been left untouched to add to the dynamic effect of the stark image on the white background.

The seed head was a mixture of steel grays, Raw Sienna, Raw Umber, and Burnt Sienna. The advantage of painting a seed head is that it does not change too much in appearance, apart from shrinking as the plant dries out. I particularly like seed heads — they produce such interesting colors and shapes as they dry, making them an ideal subject for a study.

Wisteria sinensis with pods and flowers

Used for covering walls, pergolas, and other garden structures, this is
one of the most magnificent climbing plants, loved for the perfumed
racemes of flowers in lilac-blue, pink, or white. However, I decided to
paint the wisteria for its attractive seed pods.

I removed a twisted branch with
leaves from the plant and painted it,
adding the pods later when they had
split open to reveal the dark brown
seeds inside. The stems are delightful
in the way they wind around one
another. The twisted branch was
deliberately placed to the top left
of the painting, allowing the
viewer's eye to travel down
and across the page to the
hanging seed pods. The
eye then travels around
the bottom of the page,
finally resting on the
separate study of the
open pods that reveal
the dark, almost black
seeds.

The following year, I decided to add a stem of flowers, giving me a full story of the plant within the painting. They were placed to the left-hand side of the pods to allow the eye to travel back up again to the delicate leaves and twisted stem. This composition therefore gives the life of the wisteria plant from the first leaves, then the flowers, and finally the seed pods.

Lobelia "Queen Victoria"

You may sometimes notice a plant that has grown in a particularly attractive way, as was the case with this striking specimen. "Queen Victoria" usually has tall, straight spikes, very different from the smaller bedding lobelias. This one had grown partially bent due to its planting position in relation to the light, and I decided therefore to place the painting diagonally across my paper. The stems are a deep purple, almost black in color, quite sturdy, and add a striking contrast to the brilliant red of the flowers. The leaves, also a lovely deep purple, have underlying green colors filtering through. They were painted fairly freely, using a mix of Winsor Green Blue Shade and Quinacridone Gold to give me a lively green color that was added to my Perylene Violet.

I dropped in a mix of Perylene Violet, Alizarin Crimson, and Quinacridone Magenta to achieve depth of color. I also added a touch of Indigo to the Perylene Violet and applied this in parts. The combined mix of green and red make a good dark, almost black color that was needed for the very darkest parts of the stem. The leaves were placed alongside the bottom of the stem for composition purposes to anchor the plant.

Calanthe Baron Schröder

This is one of the oldest cultivated orchids, dating back to 1894. It was grown by Frederick Sander (1847–1920), an orchidologist and nurseryman who developed a very large orchid collection in St. Albans, UK and employed more than 23 plant collectors. It is a majestic orchid that stands about 3 feet (90 cm) high, bearing flowers of the palest pink and white, with deep magenta throats.

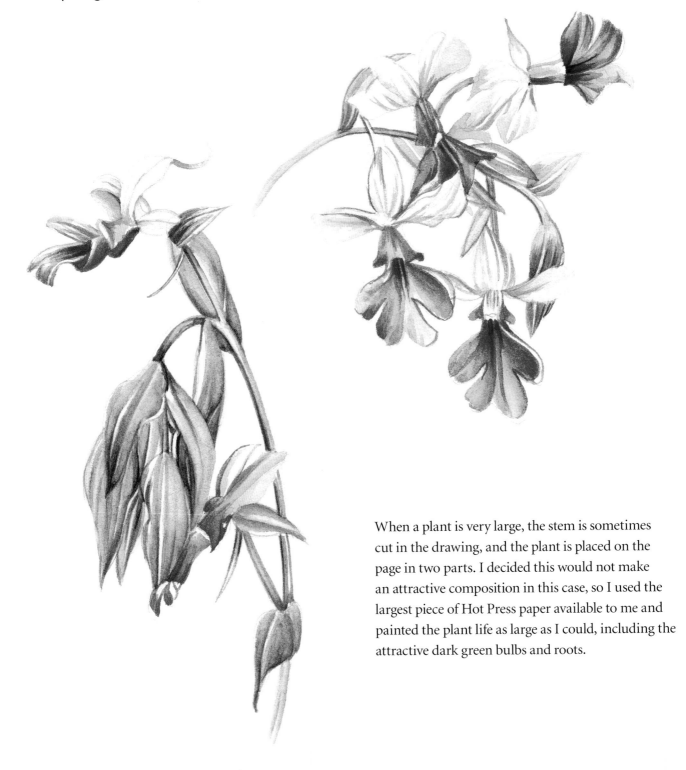

When a plant is very large, the stem is sometimes cut in the drawing, and the plant is placed on the page in two parts. I decided this would not make an attractive composition in this case, so I used the largest piece of Hot Press paper available to me and painted the plant life as large as I could, including the attractive dark green bulbs and roots.

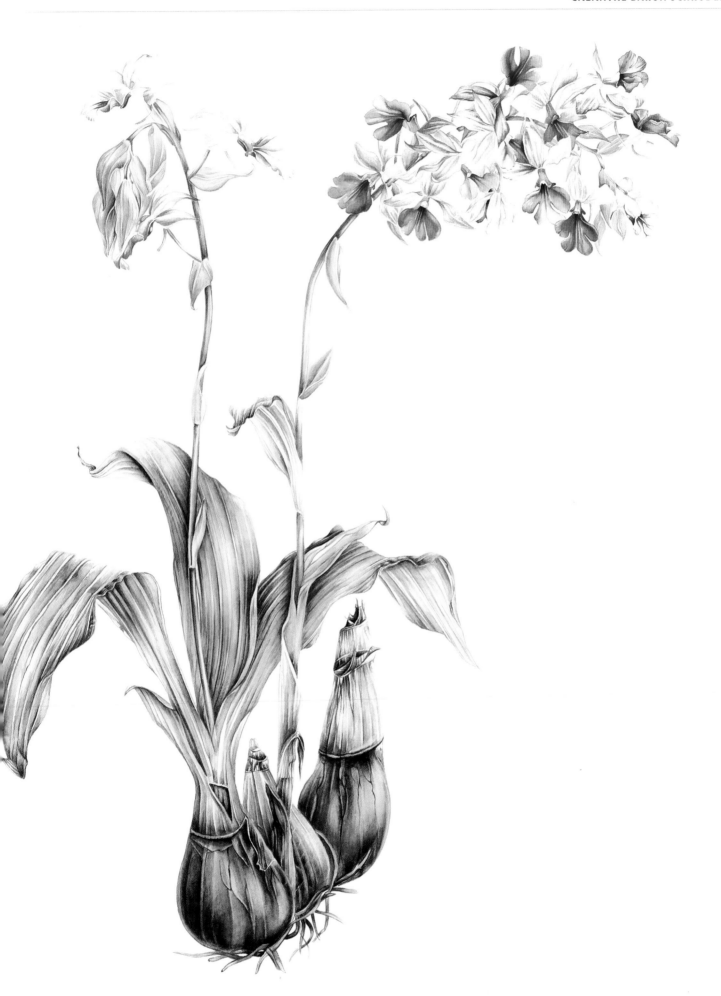

Index